SEATON &
AXMOUTH
WITHIN LIVING MEMORY

TED GOSLING & MIKE CLEMENT

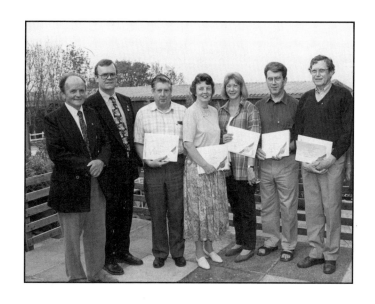

The
History
Press

For the past thirty years photographer Colin Bowerman has been recording the triumphs – and some of the tragedies – of life in Seaton for the local papers. He trained and qualified as a photographer on the *Maidenhead Advertiser* and became chief photographer there. He then spent six years in Fleet Street with United Papers followed by eighteen months with News Agency at Guildford working for the national newspapers. When he moved to Colyton in 1983 he joined *Pulman's Weekly News* and seventeen years ago he became a freelance photographer supplying images to the local papers.
(Colin Bowerman)

Title page photograph: Seaton Lions' first lady member is pictured here in May 1988.
(Colin Bowerman)

First published 2012

The History Press
The Mill, Brimscombe Port
Stroud, Gloucestershire, GL5 2QG
www.thehistorypress.co.uk

ISBN 978 0 7524 8145 6

Typesetting and origination by The History Press
Printed in Great Britain

CONTENTS

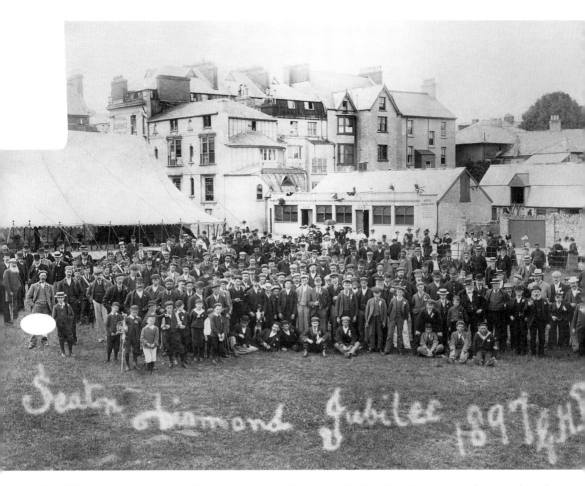

In 1897 George Barton assembled all the men in Seaton to take this historic souvenir photograph at the time of Queen Victoria's Diamond Jubilee. Along with Mike Clement from Axmouth, this book has been produced at the time of Queen Elizabeth II's Diamond Jubilee – a souvenir of the people who were in Seaton and Axmouth during the past sixty years of her reign. *(Seaton Museum)*

INTRODUCTION

Amid splendour, pomp and colourful circumstance, Queen Elizabeth II was crowned on 2 June 1953. The new monarch rode to Westminster Abbey in a golden coach pulled by eight greys, and beside her as they rode through the cheering crowds sat the Duke of Edinburgh, in full dress uniform. In tune with the rest of the country, Seaton and Axmouth's coronation celebrations were riotous, with street parties, bonfires, a sports meeting in the Cliff Field, a coronation dance and a concert in the town hall.

Shortly before the coronation many British people decided this was the time to buy a television and more than twenty million saw the ceremony on television at home, in pubs and clubs as well as gathering in small crowds to watch through shop windows.

This new book encompasses all Seaton and Axmouth life during the past sixty years or so, concentrating on people and events. The wonderful community spirit of both settlements shines through in this wonderful collection of over 200 photographs, some old, some not so old. In any case it is a valuable record of life in the area and of the people who have lived and still do live here.

Ted Gosling, Seaton, 2012

Above: Named after the new queen, here we see Elizabeth Road in 1952. Building operations for Elizabeth Road began in 1951, with the cutting of the new road from Harepath Road to Scalwell Lane. This is the road before the houses were built. *(Seaton Museum)*

Left: Looking down Fore Street, 1953. Netherhayes, seen on the left, was then a guest house and Fore Street was then home to many busy local shops. *(Seaton Museum)*

1

SEATON

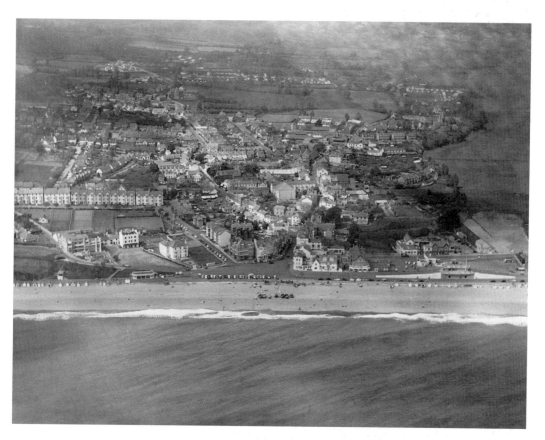

An aerial view of Seaton, 1953. *(Seaton Museum)*

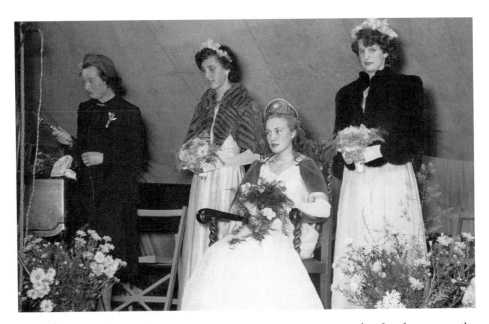

In 1952 Seaton Town Hall was still out of commission, owing to earlier fire damage, so the carnival was staged in a marquee on the cricket field. It was organised by the British Legion and the Seaton Football Supporters' Club and pictured here in the marquee is the Carnival Queen, Miss Mary Gooding, with her attendants, Marion Powling and Barbara Newton. The crowning ceremony was performed by a Mrs Shand, seen here on the left. *(Seaton Museum)*

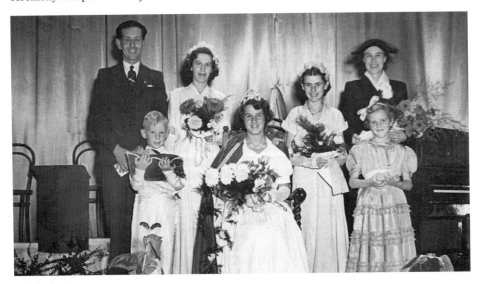

The 1953 Seaton Carnival was also organised by the Seaton Football Supporters' Club and the local branch of the British Legion. Pictured in Seaton Town Hall is the Carnival Queen for that year, Miss Sheila Tolman. Her attendants were Miss Josie Hawker and Miss Sheila Hutchings. Standing on the left is Mr Norman Tolman who was carnival chairman that year, and the carnival queen's father. The lady on the right is a local doctor's wife, Mrs Coburn, who performed the crowning ceremony. Sheila Tolman tragically passed away within a few months of this photograph. *(Seaton Museum)*

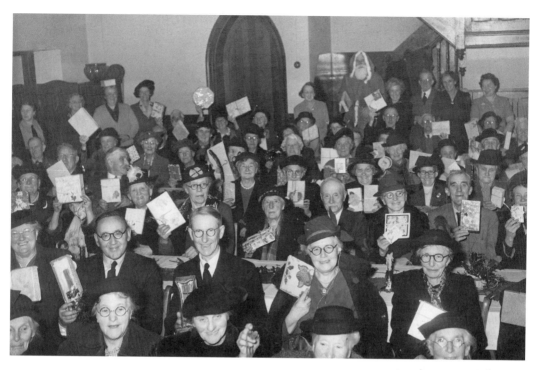

An old age pensioners' Christmas party in progress at the Congregational Church in Cross Street, 1952. *(Seaton Museum)*

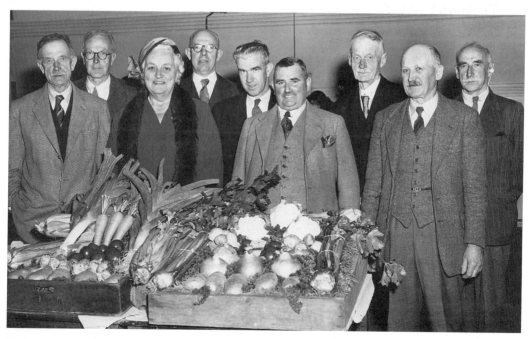

Seaton Autumn Show, 1955. This show was revived by the Seaton Royal British Legion after the Second World War. Left to right are: Mr Batstone, Captain Whippell, Mrs M. Wolstencroft, Mr H. Baylis, Mr J. Cross, Mr W. Hutchings, Mr Batstone, -?-, Mr A. Gear. *(Seaton Museum)*

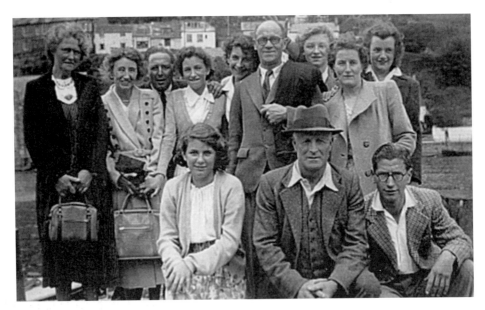

Staff and friends of Seaton post office were caught on camera enjoying a coach day trip in 1952. Seen here are Edith Newbery, Mrs Priest, Jim Priest, Wilfred Collins, Will Newbery and Mary Newbery. *(Seaton Museum)*

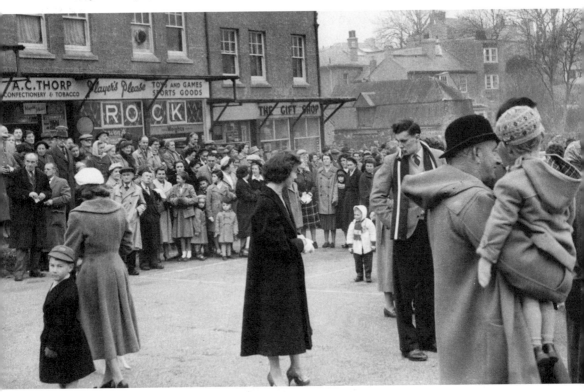

Spectators gather in Trevett car park (now the high-rise flats) in Harbour Road to watch the Boxing Day hunt meet, *c.* 1954. *(Sally Cummins)*

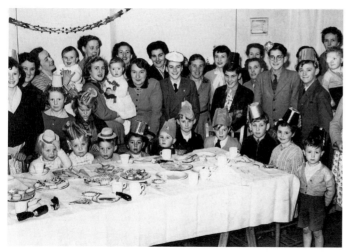

Everest Drive self-build group, *c.* 1954. Everest Drive will always remain a monument to a group of Seaton people who overcame many of the difficulties that existed in post-war Britain and formed one of the first self-build groups in the country. As the houses were finished in 1953, the same year as the conquest of Everest, the road was aptly named. In this picture we see a children's Christmas party organised by some of the mothers whose husbands built Everest Drive. *(Sally Cummins)*

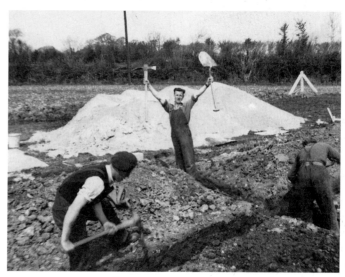

Digging the foundations for nos 11 and 12 Everest Drive in 1953 are Gordon Clements, Des Garrett (giving a victory wave with pickaxe and shovel) and Ken Gould is on the right. *(Alan Hayes)*

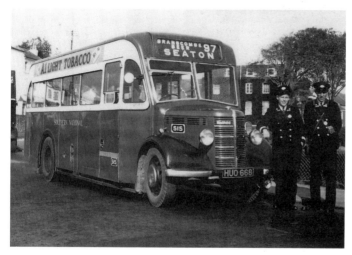

The Southern National Bus Company provided a great service from their depot in Harbour Road. Seen here in 1955 with a Bedford bus are, from left to right, driver Gordon Clements and conductor Gordon Whatley. *(Seaton Museum)*

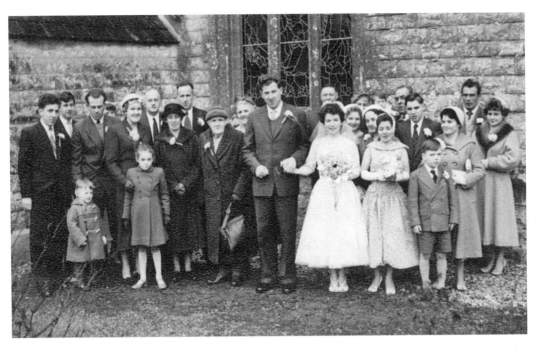

A few familiar faces here at the wedding of the well-known Seaton sports reporter Gerald Gosling to Violet Raymond at Uplyme Church, *c. 1957. (E.S. Gosling Collection)*

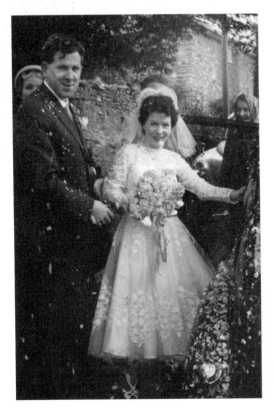

Gerald Gosling and Violet Raymond leaving Uplyme Church to go to their wedding reception. *(E.S. Gosling Collection)*

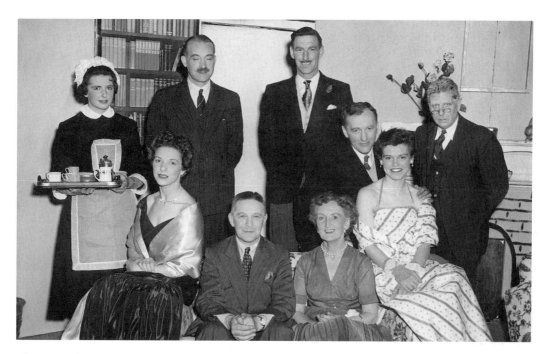

Above: Members of a theatrical party at Seaton Town
Hall, *c.* 1959. Among those photographed are
Sally Spurway, Raymond Hicks, Ralph White,
Derek Warren, Paddy Norcombe, Tony Wyatt and
Jimmy Green. *(Sally Cummins)*

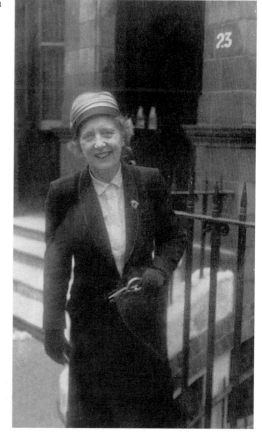

Right: Eileen Gosney, the daughter of a Seaton
chemist, who died in 1988. Miss Gosney devoted her
life to researching the history of the Axe Valley and
was well known for her lectures on the area. She
was a founder member of the Axe Valley Heritage
Museum and a one-time member of the Devonshire
Association's council. *(Seaton Museum)*

Muriel Giffard (née Head) pictured here in 1957, was the daughter of Mr W.H. Head of The Wessiters. The Head family were one of the town's oldest families dating back to 1609. Muriel, who died in 1991, was the last family member to live in Seaton. *(Seaton Museum)*

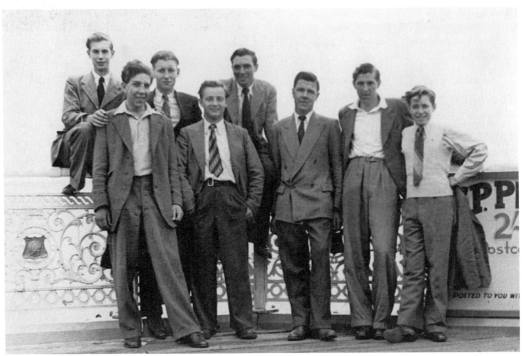

Seaton Youth Club outing to Weymouth, 1952. Seen here are Dick Moore, Don Rodgers, Henry Richard, Fred Cockram, Alan Baker, Buster Way, Arthur Critchard and Gordon Pritchard. Sadly some of these lads are no longer with us. *(E.S. Gosling Collection)*

Frank Barnicoat, who died in 1966, was a noted photographer and won many national awards for his work. He was Seaton garage owner George Trevett's uncle, and was always the perfect gentleman. *(E.S. Gosling Collection)*

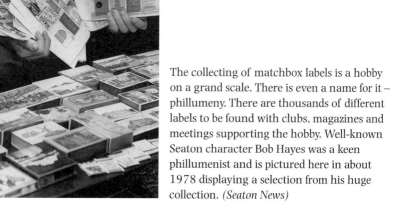

The collecting of matchbox labels is a hobby on a grand scale. There is even a name for it – phillumeny. There are thousands of different labels to be found with clubs, magazines and meetings supporting the hobby. Well-known Seaton character Bob Hayes was a keen phillumenist and is pictured here in about 1978 displaying a selection from his huge collection. *(Seaton News)*

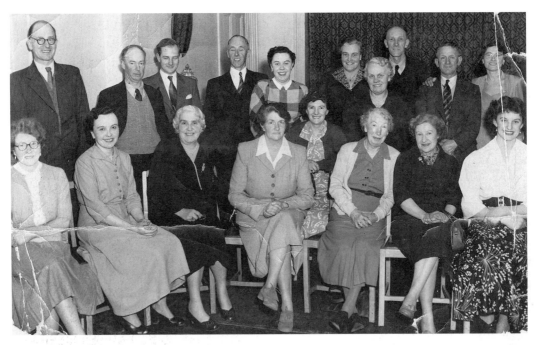

Seaton Royal British Legion dinner at the Royal Clarence Hotel, 1952. Back row, left to right: Ern Hussey, Jim Cockram, -?-, Mr Barry, Miss I. Barry, Mrs W. Hatchley, Mrs J. Real, Walt Ham, Mr Harrison, Miss Harrison. Front row: Ivy Harris, Miss D. Barry, Mrs Barry, Mrs J. Cockram, Mrs Edwards, Mrs Franklin, Mrs Tom Newton, Barbara Newton. *(E.S. Gosling Collection)*

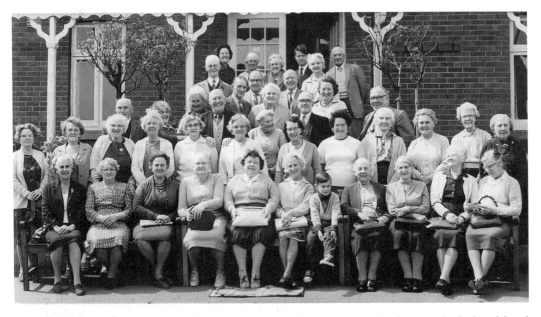

The taking of large group photographs is not easy; persuading everyone to look at you, look cheerful and keep their eyes open can present major problems. Happily, the photographer succeeded in taking this group photograph of Seaton Darby and Joan Club members on holiday on the Isle of Wight, 23 April 1966. *(Seaton Museum)*

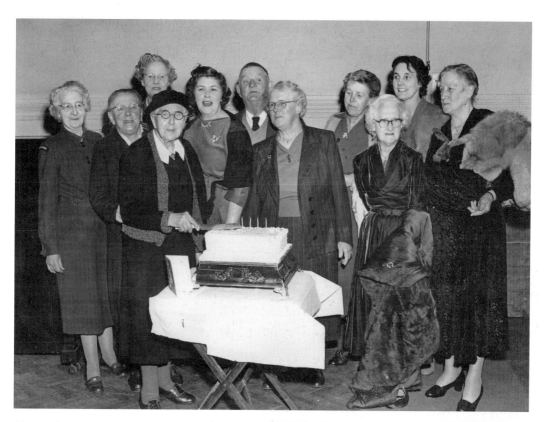

Above: The Seaton Darby and Joan Club was started in 1955 and quickly attracted over fifty members. In this photograph, taken in 1959, committee members gathered to celebrate their fourth anniversary with a splendid cake. The solitary man in the picture was Mr Sam Clapp; his wife can be seen second from the left. *(Seaton Museum)*

Right: Jim Smith, who was born in 1900 and died in 1986, was one of the most respected men in Seaton. The high-class ladies and gentlemen's hairdressers started by his father Mr W. Smith in Queen Street was carried on by Jim and his brother Len, and later by his son Maxwell until the second half of the twentieth century. *(Maxwell Smith)*

Frank Norcombe can be seen here on the right with his wife, Paddy, on the left, taken at a function in Seaton Town Hall in 1964. The little girl in the front of this picture is his granddaughter Beverley. To everyone he was Frank Norcombe, but he was christened Harold Frederick, Frank being a nickname given to him when he was apprenticed to an Exeter garage, where he was told, 'the last boy was called Frank so we shall call you the same.' Frank went to Seaton in 1929 as manager of the former Central Garage and in 1934 with Hughie Dack set up Auto Services garage in Queen Street, now a car showroom for a business continued by his family. In 1936 Frank and a number of others stood against the 'old guard' on Seaton Urban District Council, using a lorry owned by one of their number, builder Ben Turner, for electioneering. They were so successful that they changed the face of the council. Within a few years Frank became council chairman. He was made a JP and was known for his fairness, not letting local knowledge colour his decisions but deciding cases based on the merit of evidence.

Over the years he became involved with many local organisations, particularly local amateur dramatics. He brought the first St John Ambulance to Seaton in 1939, and was its driver for many years. He gave up in the late 1970s or early '80s after the NHS provided an ambulance service. Frank was also a special constable and a member of the Civil Defence Committee, and also served on a committee which gave help to prisoners on their discharge from gaol. He was for some time also the chairman of the local Conservative committee.

A quiet, kind and courteous man, he was never known to lose his temper and never listened to idle gossip. Frank was an eloquent speaker and was often called upon to open numerous functions. He died in 1989 but his name lives on through a development on the seafront named Norcombe Court.
(Joan Norcombe)

Above: David and Gareth Mettam and David's son Gary, aged ten, in 1978. This was Gary's first cup and he went on to win many more including the Otter Class National Championship in 1983. In 1958 Gareth and Bernie Webber from Axmouth built an Axe One design each (a 12ft 3in clinker dinghy). Sadly Bernie's was lost in a gale but Gareth sailed his with great success for many years. In 1964 he won every cup at Axe, his wife Gloria winning the ladies' cup and his crew, Alan Smith, winning the crews' cup. Also in this photograph is Bunty Harwood (wife of Commodore Ron Harwood); Walter Hall, Commodore 1975–8; Dennis Poulton, a regular cup-winner and National Champion in the Phantom dinghy class in 1977–8; and Stephen Daniel who, after many successes at Axmouth, went on to win the Contender World Championships in Brisbane. *(David Mettam)*

Right: David Mettam receiving a trophy from the chairman of the Seaton UDC at Seaton Regatta in the mid-1950s. David joined the Axe Yacht Club in 1950 and was commodore from 1969–72. He won his first senior cup in 1959 and has been winning cups up to the present day, in 2011 winning four AYC cups and the Lyme Regis regatta in his cruiser *Arun. (David Mettam)*

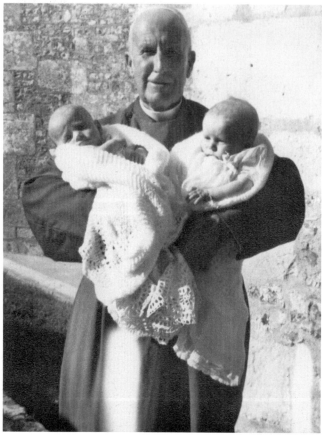

Above: Kenneth Harman Young was born on 13 July 1887 in Dorking, Surrey. He was twice wounded in the First World War and his daughter Daphne published his war diary, which documents the horrors of that terrible time. Kenneth, who first visited Seaton in the early 1890s, moved here in 1940. He loved Seaton and in return Seaton loved and respected him. After several years of ill health he died on 19 November 1970. *(Daphne Harman Young)*

Left: The Revd Harry Cooke was the much-loved vicar of Seaton who became a prebendary in Exeter Cathedral. In 1964 he came from the cathedral to Seaton to christen the twins Paul and Marie Richards. *(June Richards)*

Right: Seatonian Dick Moore, who sadly passed away in 2005, is seen here with his wife Patricia and daughters Joanna, Paulette and Rowena. Joanna was born in an ambulance driven by the late Frank Norcombe along the Clyst St Mary bypass. *(Pat Moore)*

Below: Jack Spurway, as so many will remember him, at the wheel of a coach. He drove on tours for the Southern National and is seen here in July 1969. *(Sally Cummins)*

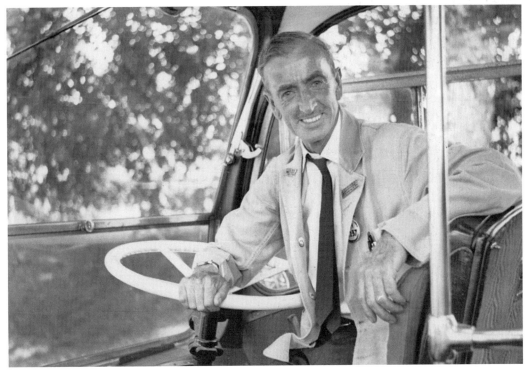

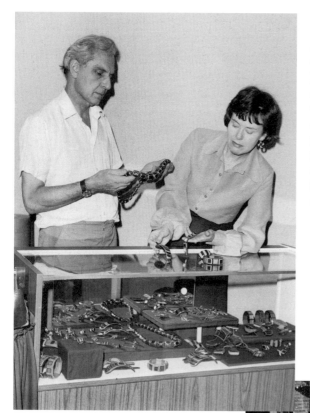

Seaton people were fortunate when, in 1975, Edwin Spencer and his wife Ann decided to come to live in the town, setting up a craft shop. This offered genuine handmade articles created by individual craftsmen. Edwin (1918–98), seen here with Ann in 1975, originally trained as a cabinet maker. During his final year he produced work that gained an award at the international exhibition at Brussels in 1935 and he was later chosen to make a cabinet for presentation to Her Majesty Queen Mary. *(Seaton Museum)*

Miss Elizabeth Gosling is pictured here in 1970 enjoying a cup of tea. Known to all as 'Aunt Ciss', she was much loved for her wonderful sense of humour. She delighted in taking out trays of tea to any builder or road repairer who was working outside her house in Sidmouth Street. *(E.S. Gosling Collection)*

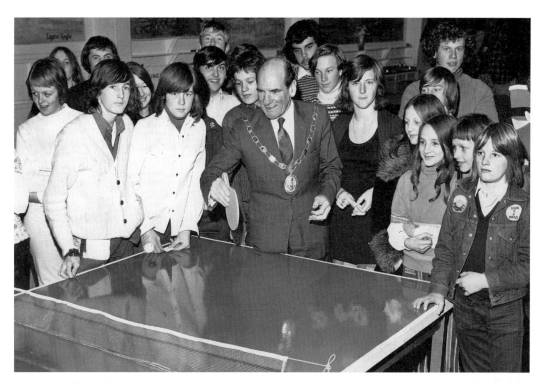

Mr George Clare, Chairman of the Seaton Urban District Council, is pictured here trying his hand at table tennis with members of the Seaton Youth Club, 1973. *(Seaton News)*

A few recognisable characters can be seen here in the King's Arms in about 1971. Landlords Dick Spiller and Gilbert Hutchings are in the centre receiving an award.
(Seaton News)

Mrs A.D. Parnell, the wife of the proprietor of the Seaton Regal Cinema, trained talented groups of local girls from 1962 until the 1970s into dance troupes. The Regal Cinema Girls' Club were in local pantomimes and gave many concerts, and went under the names of the Regalettes, the Teeny Puppets and the Teenage Paraders. They are seen here in 1974.
(Seaton Museum)

Nearly 300 people attended an event staged by Seaton Chamber of Trade and the Hotels and Restaurants Association in aid of a fund required to produce the local holiday guide in 1975. Pictured here are members of Mrs Parnell's dance troupe the Teenage Paraders, who provided some of the entertainment at this event, which was held in the Seaton Town Hall.
The MC that day was Tony Burgess, chairman of the Chamber of Trade.
(Seaton Museum)

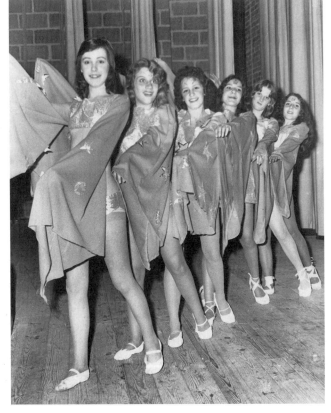

Right: Mrs Thody is pictured here at her spinning wheel doing a demonstration at the opening exhibition of St Clare's, 1970. She always used natural dyes from hedgerow plants to colour her yarns. *(F.C. Sturgiss)*

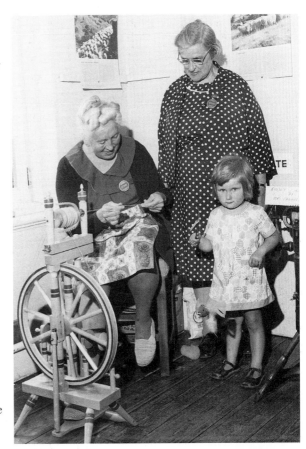

Below: The Seaton Camera Club stand at the opening exhibition held in St Clare's, 1970. *(F.C. Sturgiss)*

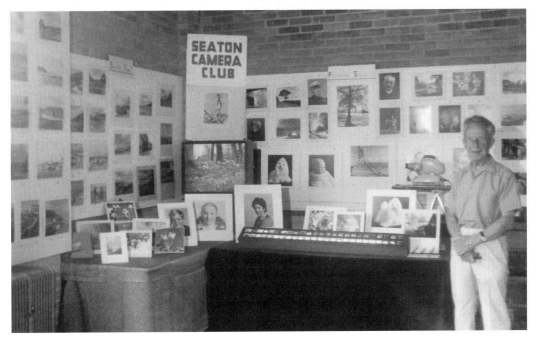

Mrs Parnell's girls taking part in Seaton Carnival, 1966. *(Seaton Museum)*

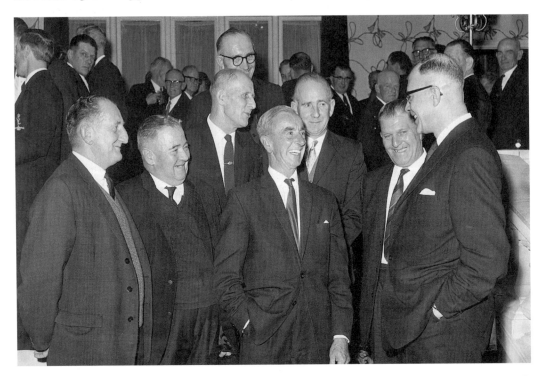

Jack Spurway, Southern National and Royal Blue bus driver, can be seen here in the centre of the photograph at a Southern National staff function. *(Seaton Museum)*

The daughters of Mr William Smith, photographed in Seaton on Christmas Day 1973. Mr and Mrs William Smith once owned the local newsagent. Left to right: Mrs Estelle Smedley (the eldest daughter, who once ran a toy shop in Queen Street), Miss Gladys Smith (a popular local figure), Mrs Joyce MacLean (who married an Australian and emigrated to New South Wales), and Mrs Phyllis Adams (who emigrated to Canada). These four Seaton sisters were reunited for the first time since 1918 and three of them reached the grand old age of 100. *(Seaton News)*

The staff of Seaton drapers Ferris and Prescott in 1964. This group is enjoying a celebration lunch at the Bay Hotel, Seaton. Mr Sydney Ferris is sitting at the head of the table with his wife on the left. Others present included Mr and Mrs W. Nex, Mr and Mrs Powling, Misses Anning and Hayman and Mrs Clement. The shop in Queen Street traded successfully for over forty years until the retirement of Mr Ferris in 1974. *(E.S. Gosling Collection)*

Seaton Bowling Club. Situated in a sheltered spot in the centre of Seaton the bowling green is an asset to the town. The green was opened in 1929, while prior to that the game was played on rinks in Colyford Road. Tom Hilder, captain of the bowling club, is throwing up a wood on the opening day of the new season. The ceremonial silver jack was sent down by the acting president Mr W.H. Smith. *(Seaton News)*

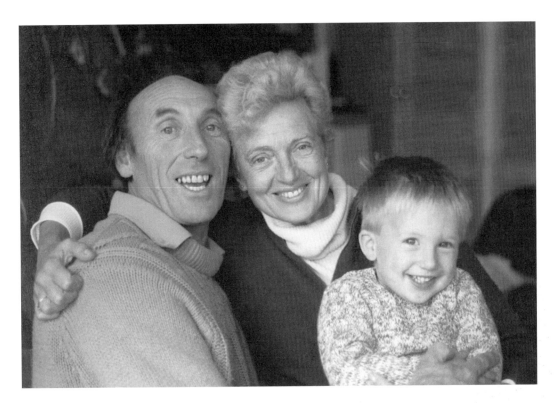

Well-known and popular Seatonian Alan Hayes is pictured here with his wife Ida and grandson Dean. *(Sally Cummins)*

Mrs Joyce Hartnell is seen here on 24 September 1983 holding the framed pieces of Honiton lace which she had made. The lace was made in the memory of a Mrs Lloyd who had been treasurer of the day centre, held in the morning at Seaton Town Hall. Mrs Willis, seen on the left, organised the day centre for many years and during her time the centre for elderly people, who could drop in and enjoy coffee and biscuits and stimulating conversation, was really popular and successful. *(Seaton Museum)*

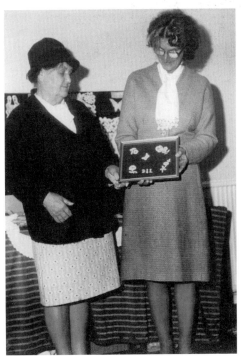

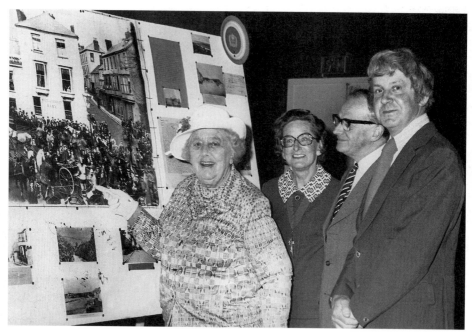

1977 was the year of Queen Elizabeth II's Silver Jubilee and Ted Gosling, local historian, organised an exhibition in Seaton Town Hall to celebrate the event. Seen here, left to right, are Eileen Gosney, who performed the opening ceremony, Mavis Williamson (council chairman), Don Isgrove and Ted Gosling. *(Seaton Museum)*

Earle Richards enjoying his retirement after spending all his life in the family firm G.H. Richards and Sons. Earle and Archibald, the two sons, spent most of their working lives building and maintaining the properties constructed by their father George Henry. *(June Richards)*

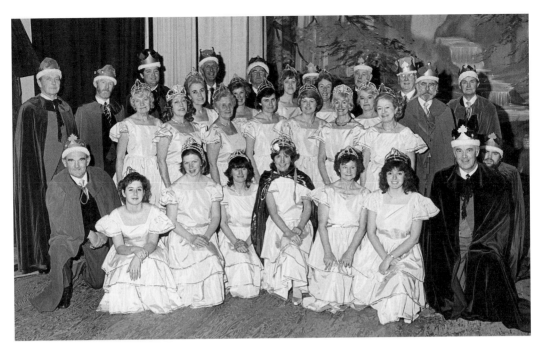

The Axe Vale Amateur Operatic Society performed Gilbert and Sullivan's works for many years and here we have the cast of *Iolanthe*, in April 1988. If you did not know the story, Iolanthe was a fairy princess who fell in love with a mortal and was banished to live with the frogs. *(Colin Bowerman)*

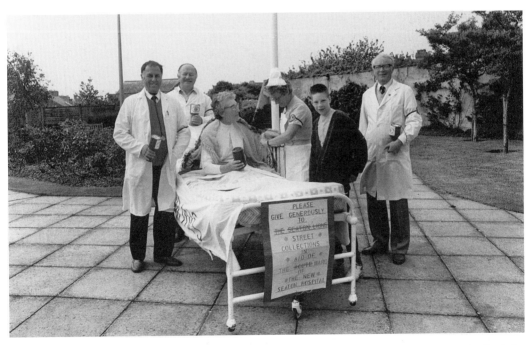

Mary Wood is seen here being pushed around the town on a hospital bed by Seaton Lions to raise funds for the new Seaton Hospital. *(Mary Wood)*

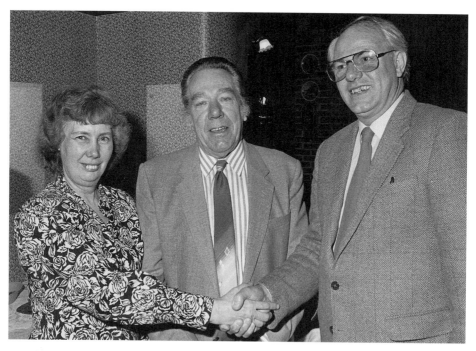

Alan Tawse became the new chairman of the Seaton and District Hotels and Restaurants Association during January 1989. He is seen here on the right of the picture with former chairman Mrs Dorothy Lomas, and the Hoteliers' President Fred Hocking. *(John Fletcher)*

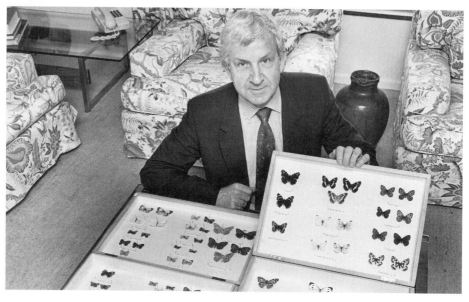

The Axe Valley Heritage Museum in Seaton Town Hall was handed a unique collection of butterflies from the Axe Valley in November 1987. Curator Ted Gosling is pictured here with the cases of butterflies which were captured by the late Douglas Cottrill, whose family had given the collection to the town. The collection includes precious specimens such as the Green Hairstreak and migrants from the continent like the Painted Lady and Clouded Yellow. *(Colin Bowerman)*

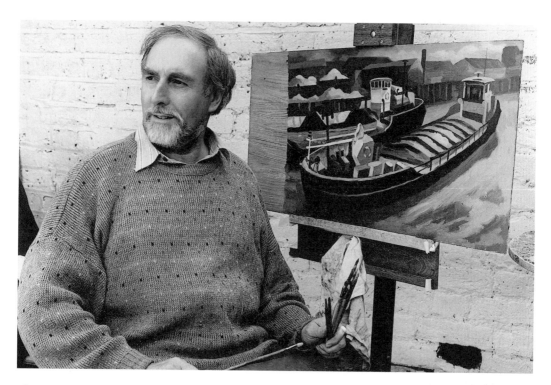

Above: Terry Scales at work on his Deptford Creek oil painting, 1990. Terry arrived in Seaton in 1940, an evacuee from South London. His time in Seaton was one long adventure and probably the most significant experience of his life. Being so closely in touch with nature sowed the seeds of his future career, that of landscape painter. *(E.S. Gosling Collection)*

Right: Edna Everitt, Seaton Museum founder, came to Seaton when her husband retired in 1975 and she did some occasional relief teaching at Axminster Primary School. Edna became Secretary to the Friends of the Museum and contributed much to the finances by organising coffee mornings. The success of the museum's supportive friends was due to the hard work that Edna gave over the years. *(Seaton Museum)*

Above: Violet Webster pictured here in 1989. Her father was Herbert Good who owned the Cliff House Hotel on Castle Hill. The Goods were one of Seaton's oldest families and Mrs Webster possessed an unrivalled knowledge of her native town. *(Seaton Museum)*

Left: The Phillips sisters, who have all now sadly passed away, were pictured here at the seventieth birthday lunch for Seaton Museum Chairman Roy Chapple at the Kettle restaurant, 2001. They were great supporters of the museum and were stewards for many years. *(Seaton Museum)*

Seaton marathon man Harry Moore is seen here taking part in the Great Western Run, 5 May 1996. Harry started running competitively in 1984 when he took part in the Torvill and Dean Olympic Appeal. By the end of April 2003 he had completed 745 runs including 130 half marathons. His achievement earned him a place in the Devon athletic record books, and he just missed out on being in the *Guinness Book of Records*. By 2012 Harry had completed over 1,000 runs – well done that man! *(Harry Moore)*

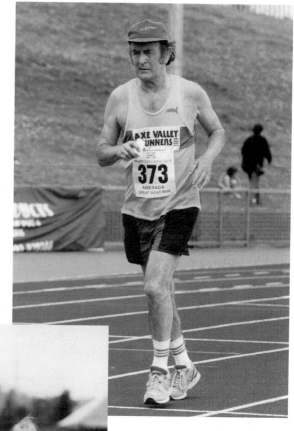

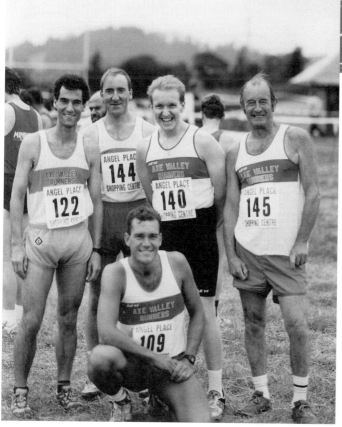

Members of the Axe Valley Runners who took part in the Bridgwater Half Marathon. Left to right: Steve Boyes, Steve Atkins, John Masson, Harry Moore. Steve White is kneeling in front of the group. *(Harry Moore)*

Above: Jack Spurway and his wife Eve are pictured here at Christmas 1981 with daughters Sally and Jenny. They had gathered at Jenny's house in Winterborne Whitechurch. *(Sally Cummins)*

Left: Ted Gosling is pictured here presenting a cup to Miss Seaton, the 1993 Seaton Carnival Queen, after the crowning ceremony, which took place on the Esplanade. Carnival chairman Rodger Woolland can be seen on the right. *(E.S. Gosling Collection)*

June and Roderick Richards are seen here celebrating their fortieth wedding anniversary in 1993. Roderick was a member of a well-known Seaton firm of builders; his grandfather George Henry Richards built many of the town's important buildings including the town hall and the Westleigh Hotel. In the 1920s he also undertook the construction of the Chine. June was an Axmouth girl, a member of the much-respected Sweetland family.
(June Richards)

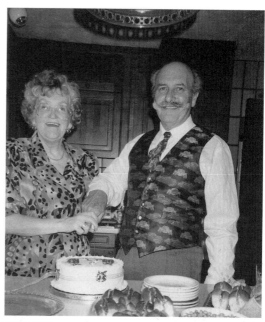

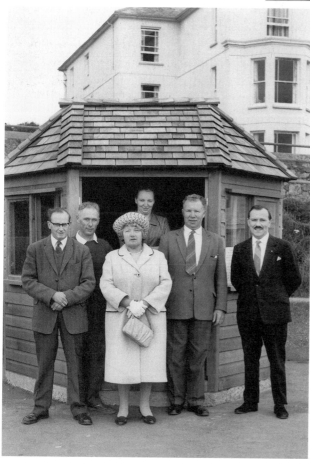

The tourist information office plays a vital role in any seaside town. In this picture we see the opening of the first information kiosk in East Devon on Seaton's West Walk, June 1965. Left to right: Donald Isgrove, Tony Byrne-Jones, Mrs Jesse Turner, -?-, Curly Webster and Roy Chapple. The information centre then moved to the Esplanade and then to the Harbour Road car park. It is sad that owing to poor planning the centre was closed in 2010 resulting in a loss of revenue to local attractions.
(R. F. Chapple Collection)

Jane Real was born on 27 April 1964. She attended Seaton Primary School from 1969 until 1974 and then Axminster Secondary School. When she left school she worked at Racal (Seaton) in the drawing office until 1987 when she and fifty-eight other employees were made redundant. She then applied for a traffic warden's post which she got, and worked at Sidmouth for two years. After two years she went to the Devon and Cornwall Constabulary at Middlemoore, Exeter, where she worked as police support personnel. In 1998 she was diagnosed with breast cancer and because of ill health, she left Middlemoore in 2000. She then invested in the ice cream kiosk on the West Walk on Seaton's seafront known as Jane's Kiosk which is now run by Jane's youngest brother Jeremy. Jane sadly died in October 2000 aged thirty-six, and is much missed by her family and many friends. *(Derrick Real)*

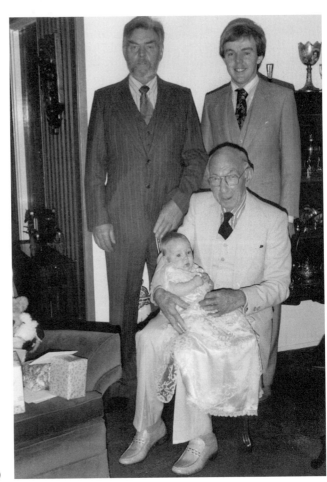

Rightly named 'Mr Seaton', Frank Norcombe is seen here with his son Brian, grandson Jeremy and great-grandson Damien. *(Jo Norcombe)*

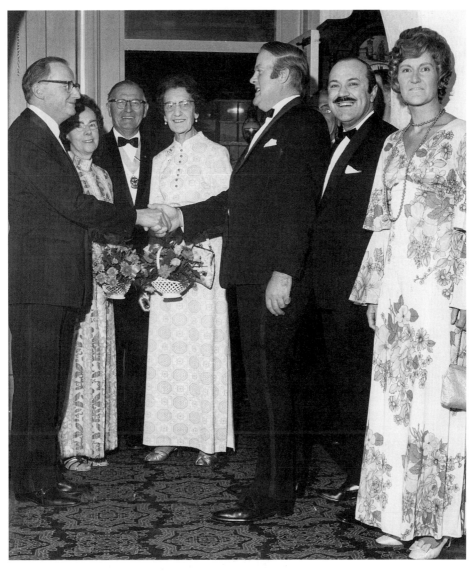

Local dignitaries at a Rotary evening. Left to right are Mr and Mrs Isgrove, -?-, -?-, Mr Chubb, Roy Chapple and Ann Clare. *(Seaton News)*

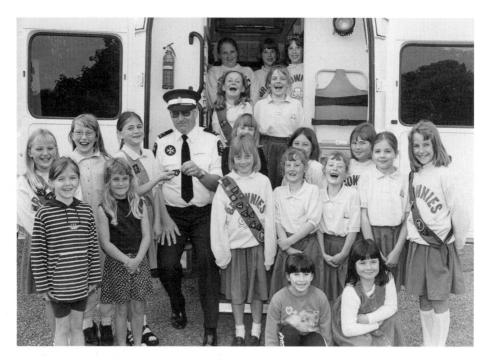

Fred Hansford is seen here in June 1998 presenting Seaton Brownies with their first aid badges. With the help of the local St John Ambulance Brigade, they had worked hard to gain these awards. *(Colin Bowerman)*

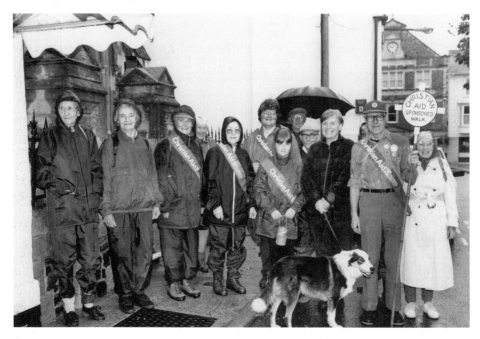

Christian Aid sponsored walk, 1 October 1998. Organised by Mr Arthur Wright, parishioners from seventeen East Devon churches, along with members of Axe Valley Runners, braved the elements to take part in a charity walk. *(Colin Bowerman)*

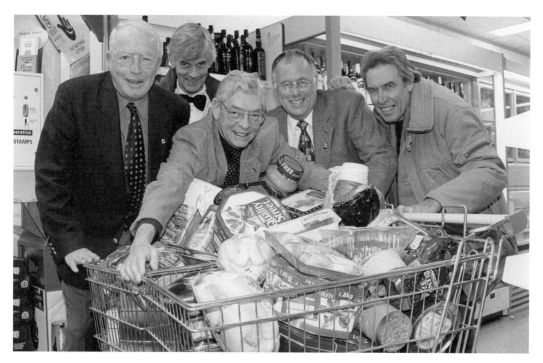

The Christmas Trolley Dash, organised by the Seaton Lions, raised £700 in ticket sales. Pictured here, in December 1998, is the winner Mr Gwyn Hall (centre) with his trolley stacked with over £300-worth of Christmas goodies. Pictured with Gwyn are Peter Maddox, Lions Vice President; Adrian Brewer; John Cook, President and Bob Buskin. *(Colin Bowerman)*

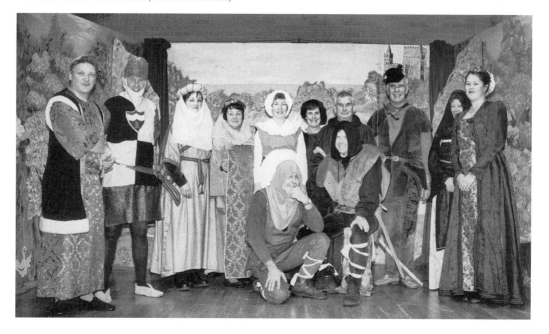

Here we see the cast of John Seaward's pantomime at Seaton Methodist Church, *Robin Hoodwink and his Very Merry Men*, January 1999. *(Colin Bowerman)*

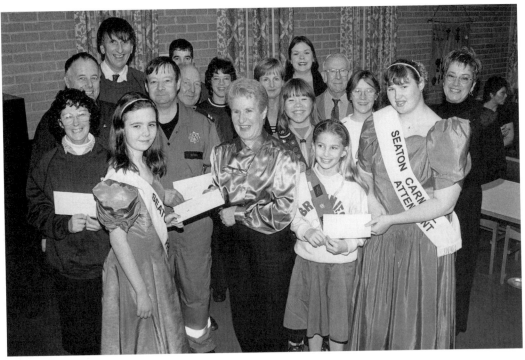

Seaton Carnival Queen Marie Frost, and her attendant, Sarah Hunt, can be seen here during a cheque presentation, December 1999. Twenty-three groups received a share that year from the carnival profits which totalled £1,700. *(Colin Bowerman)*

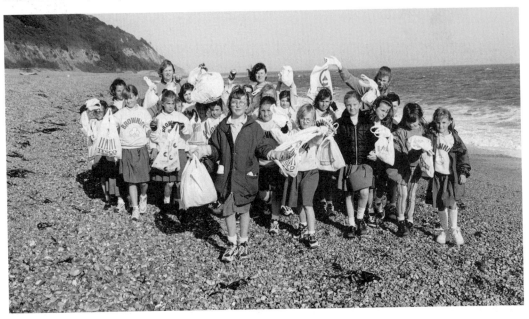

A good job well done. Seaton Brownies did their bit for the environment when they spent an evening during May 1999 clearing rubbish from the beach. Fifteen bags were filled in about 90 minutes despite the strong winds at the time. *(Colin Bowerman)*

Twitchers get ready to travel to view the River Axe and its wading birds. The journey was organised by the Seaton and District Conservation Society. More than thirty people boarded the trams run by Seaton Tramway. *(Colin Bowerman)*

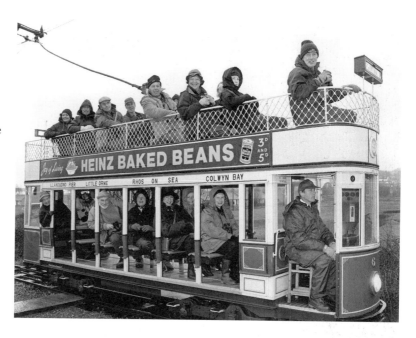

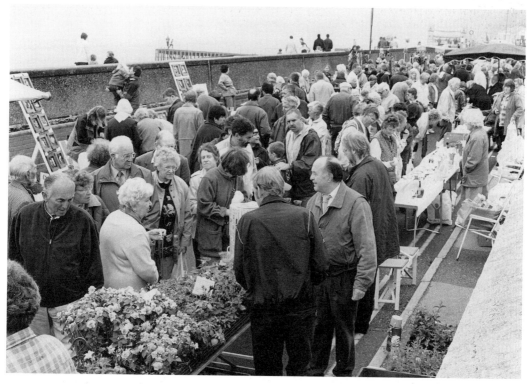

The proliferation of shops in the nineteenth and twentieth centuries put paid to much of the old-style street vending. However, here in Seaton, during a bank holiday weekend in June 1999, a return was made when the sixth annual Street Fair was held on the Esplanade. The fair was organised by the Lions Club of Seaton and pictured here are visitors and locals browsing some of the many stalls. *(Colin Bowerman)*

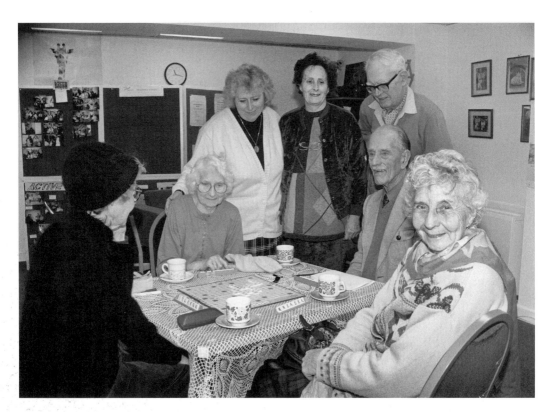

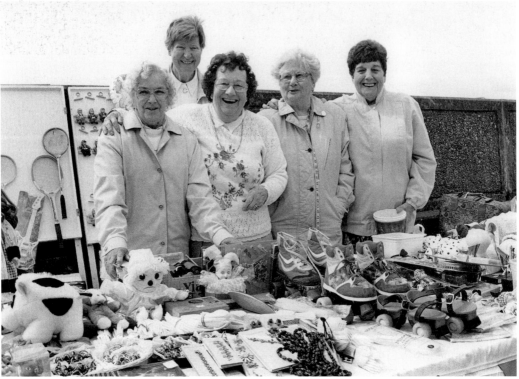

44

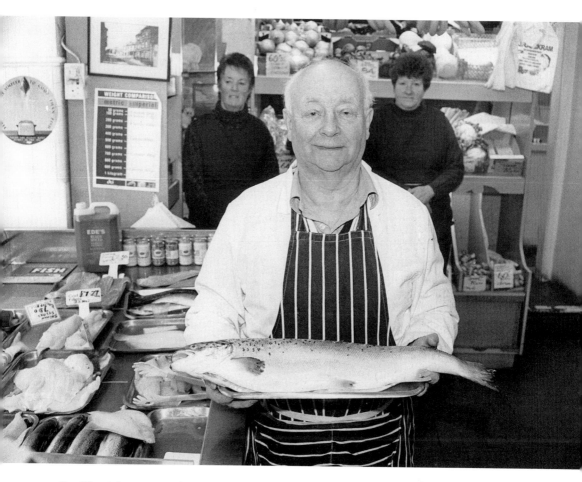

For fifty-eight years Fred Cockram's shop was a familiar part of Seaton's town centre selling fish, game and fresh fruit. On 3 March 2001 Fred, aged seventy-one, closed the business because his lease on the property in Queen Street had expired. The shop was a great asset to the town and is very greatly missed. *(Colin Bowerman)*

Opposite, top: Pensioners enjoying a Thursday morning Scrabble session at the Age Concern centre in Seaton, February 1999. *(Colin Bowerman)*

Opposite, bottom: Looking after the Cancer Research stall on a Bank Holiday Monday at Seaton Lions' Street Fair in June 2000 are, left to right, Kay Holding, Honour Lingwood, Molly Gould, Vera Lock and Daphne Garratt. *(Colin Bowerman)*

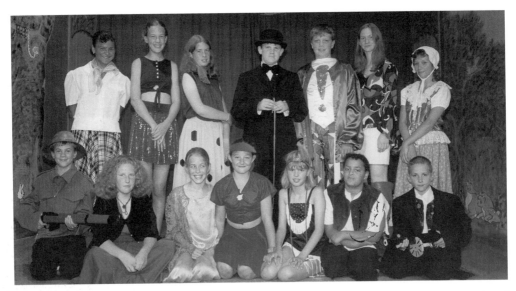

The theatre group STARs was formed by Lynne Derrick in 1999. Their first production, *A Musical Centenary*, was staged in July of that year at the Methodist church in Valley View. In November 1999 the group performed Dickens' *A Christmas Carol* at Seaton Town Hall under the direction of Anne Giles. April 2000 saw a stunning performance of *The Wizard of Oz* followed in November with *Toad of Toad Hall*. Their subsequent productions have included *Alice in Wonderland*, *The Cat* and *The Dracula Spectacular Show*. All the cast are aged between ten and sixteen and much credit must go to the children and the dedication of Lynne Derrick. Above we see the cast of STARs' first production *A Musical Centenary* and below are the cast of *The Wizard of Oz* which was staged in Windsor Gardens in April 2000. *(Colin Bowerman)*

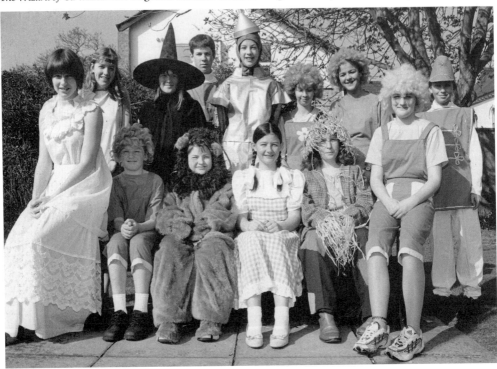

Seaton Lions Club gave cheques totalling £1,905 to eight charities at a presentation in the Pole Arms in March 2002. Lyme President Dennis Morgan is pictured presenting the cheques. *(Colin Bowerman)*

Seaton Town reserves, October 2001. Back row, left to right: Gary Pinnock, Ross Newton, Dave Cottam, Matthew Eates, Philip Martin, Joe Moore, Daniel Parker, Charlie Ziemann (manager). Front row: James Gular, Ewen McClean, Wayne Ridout, Ross Lambert, Craig Hopkinson, James Cope, George Moore. *(Colin Bowerman)*

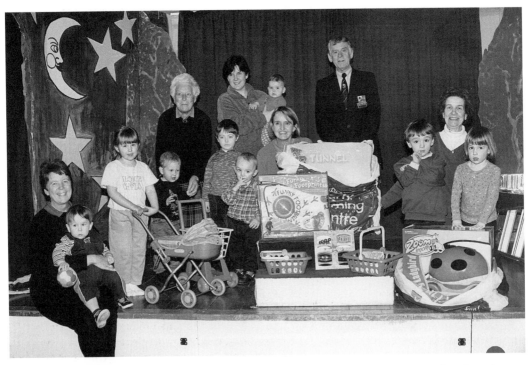

Above: Seaton Lions president Dennis Morgan is seen handing over hundreds of pounds' worth of new toys to mums of the Tea and Tots Club, which met at the Seaton Methodist Church, March 2001. *(Colin Bowerman)*

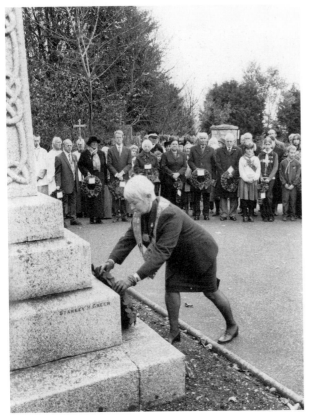

Left: Seaton remembers. Town Mayor, Rosemary Partridge-Hogbin, lays a wreath at the war memorial at St Gregory's Church for the Remembrance Day ceremony, November 2003. *(Colin Bowerman)*

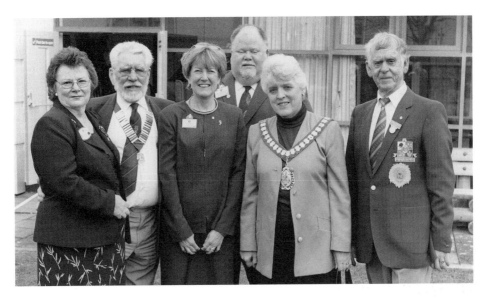

Seaton Lions Club played host to Lions Clubs from around Devon during a weekend for the annual Lions convention which took place in March 2004 at the Lyme Bay holiday camp. The convention was officially opened by Ann Liverton, the chairman of East Devon District Council. Pictured here at the opening are Joan Halford, John Halford, the district governor; past international director Ross L. Thornfinnson and his wife Linda from America and Ann Liverton and Dennis Morgan of Seaton Lions. *(Colin Bowerman)*

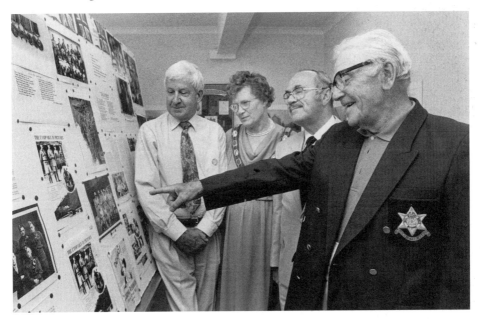

Arthur Stringer, proudly wearing the Burma Star on his blazer, can be seen here opening the VJ Exhibition in Seaton Museum, August 1995. This event commemorated fifty years since the war with Japan had ended. Left to right: Ted Gosling (Curator), Barbara Dearden-Potter (Chairman, Seaton Town Council), Roy Chapple (Chairman, Axe Valley Heritage Association) and Arthur Stringer. *(Colin Bowerman)*

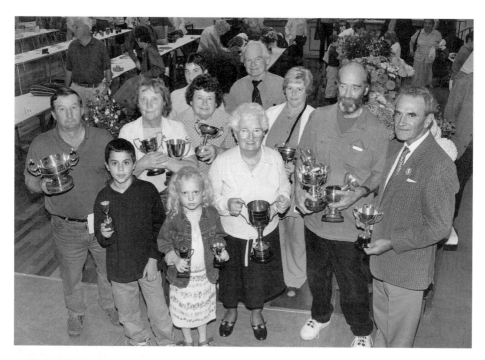

Above: President of the Seaton and District Autumn Show, Dr David Lawrey, is pictured here in October 2000, presenting the trophies at the show held in Seaton Town Hall.
(Colin Bowerman)

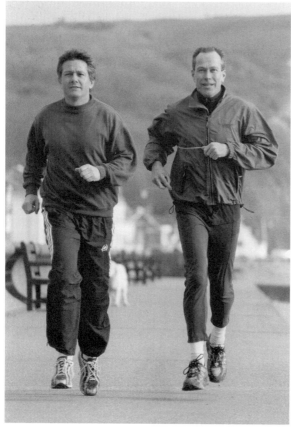

Left: Two local doctors, Joe Pitt and Julian Hurst, are pictured on the seafront training for the Axe Valley Grizzly, from which they intended to raise money for the Seaton and District Hospital and the Asian Tsunami Appeal.
(Colin Bowerman)

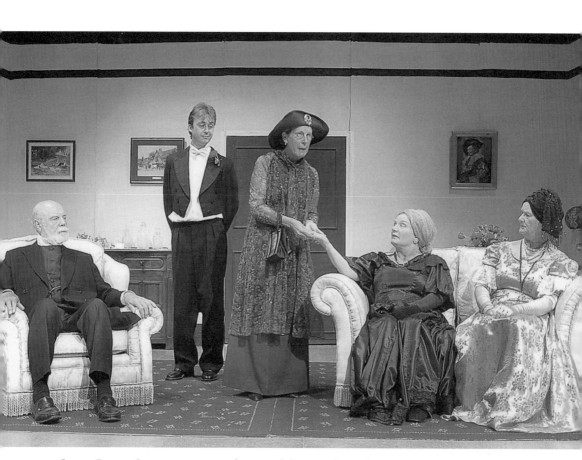

Seaton Drama Group put on its production of the comedy *Lord Arthur Savile's Crime* at Seaton Town Hall, 21 June 2006. Members of the cast appear here in a scene from the play where a fortune teller reads palms. *(Colin Bowerman)*

Sandra Semple was Seaton's mayor from 2007 to 2010. She was elected with other councillors representing the Stand Up For Seaton Group which opposed the construction of the large supermarket which now dominates the town. Married to James, a retired university lecturer, Sandra is now involved with the group endeavouring to save the adult education centre for the town.
(Sandra Semple)

Peter Dunsford joined the Devon Constabulary (Constable 97) on 23 August 1946, and served for thirty years, retiring on 27 August 1976. From 1962 Peter was a Seaton policeman where he remained until retirement. He had been a prisoner of war for five years during the Second World War and his story is recorded in 'Five Years Behind Bars' in the book *The Call of Duty*. PC Dunsford, who died in recent years aged ninety-two, always upheld the proud tradition of serving and protecting the public.
(E.S. Gosling Collection)

Councillor Jim Knight has been married for forty-five years to Connie and has two children and three grandchildren. He was first elected to the town council in May 1991 where he held position of mayor three times, deputy mayor six times and was chairman of many committees during his term of office. He sadly resigned after twenty-one years' service to the town. During this period he was elected to the East Devon District Council from 1999 to 2003 where he held the position of vice-chair of housing allocations then chair of housing allocations. Re-elected in 2005 (to the present day), during this time he has held the position of vice-chair of a scrutiny committee and vice-chair of the licensing and enforcement committee. In 2009 he was elected to the county council where he was vice-chair of the school transport committee, moving to chairman in 2011 as well as being vice-chair of the East Devon County Committee. He also chairs many employment appeal hearings. In addition to this he has been a Seaton school governor since 1997 and held chair of finance and personnel for many years and vice-chair of governors, graduating to chair of governors in 2010. He has recently taken on a governorship for Devon County Council at the Acorn Federation where he was made a chairman of resources. With a few other hardworking people of the town, Jim started up a charity called Seaton Phoenix, which supports disadvantaged people in the town and helps local voluntary groups. With two of the past Seaton mayors he has just started a company called Friends of St Clare's, to enable the town to save a community building. Jim was also elected president of the Axe Valley Runners in 1997, a position he still holds at the time of writing. *(Jim Knight)*

Seaton Town Football Club, May 2007. Players celebrate their win over East Budleigh in the Seaton Challenge Cup final. *(Colin Bowerman)*

The annual meeting of the Seaton Carnival committee held in the town hall during November 2007. The profits from that year's events were presented to local groups. The carnival's royal party can be seen here presenting some of the cheques. *(Colin Bowerman)*

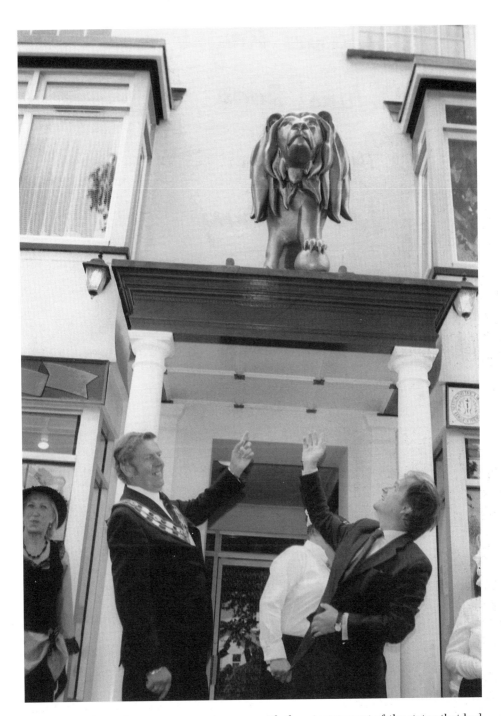

Golden Lion Day at Seaton was a great success with the reinstatement of the statue that had stood over the Golden Lion Inn in Fore Street until the 1960s. Local MP Hugo Swire unveiled the lion with the town mayor, Cllr Jim Knight, while the retiring mayor, Cllr Rosemary Partridge-Hogbin, also attended the ceremony, 11 June 2004. *(Mr Westmancoat)*

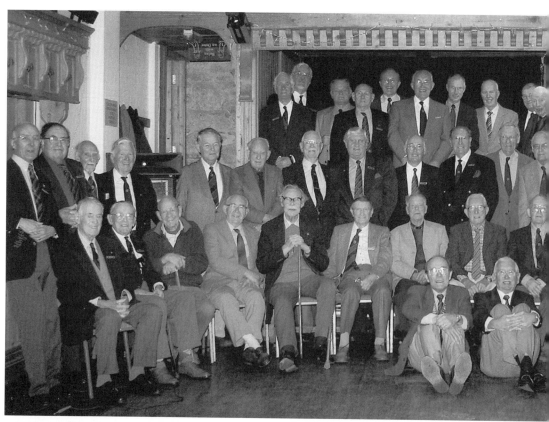

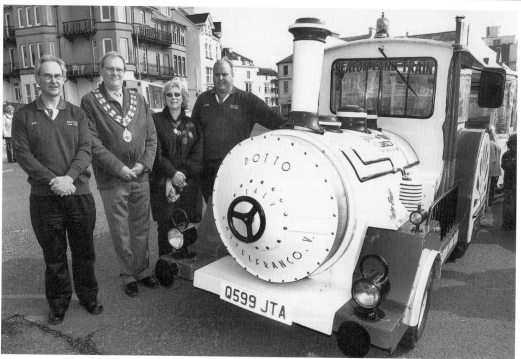

This is an excellent group photograph of the Seaton Probus Club, an organisation for retired and semi-retired businessmen and professionals. They had gathered at Winston's in Harbour Road for this picture taken for their 500th meeting on 29 November 2006. *(Keith West)*

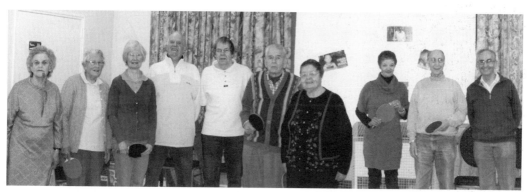

St Gregory's Church members have formed a table tennis club which meets in the church hall. Left to right: Ellen Gunner, Joyce Colman, Jo Bull, Stan Crompton, Brian Fifield, Rod Macuaig, Dorothy Holman, Carol Gosling, Tony Fiore, Jeff Packman. *(St Gregory's Club)*

Opposite: A much-missed attraction, the Land Train, is seen here on its first trip to Beer. The town mayor along with the Land Train owners are also pictured on Seaton seafront in April 2007. *(Colin Bowerman)*

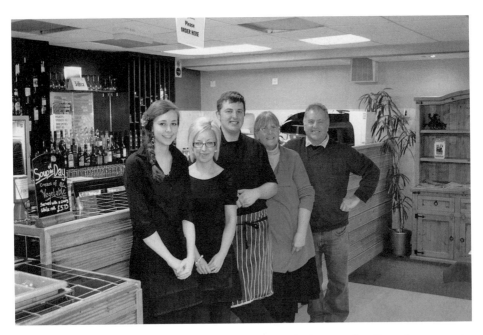

Over the past sixty years, Seaton has always had a good selection of cafés and restaurants, providing a service to holidaymakers and residents alike. Here in January 2012 the staff of the Seaton restaurant, Temptations, pose for a picture. Left to right: Bethany Sibley, Nikki Vernon, Ollie Vernon and owners Pat and Jeff Fever. *(Temptations)*

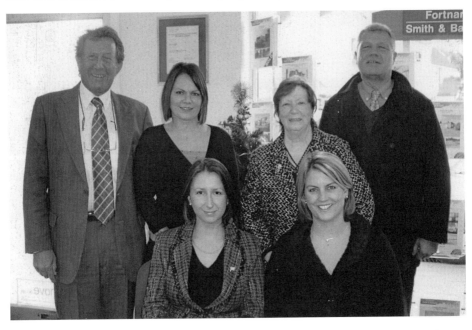

The staff of Fortnam, Smith & Banwell, Seaton independent estate agents, 2012. Back row, left to right: Arthur Banwell (director), Lisa Marsden (negotiator), Wendy Hayden (negotiator), Peter Fortnam (director). Front row: Julie White (director), Teresa Youens (negotiator). *(Fortnam, Smith & Banwell)*

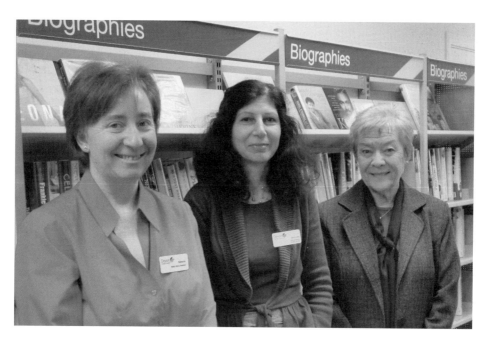

Seaton Library plays a most important role in the community. Pictured here in January 2012 (from left to right) are library assistants Rebecca Mayfield, Skevoulla Hambi-Hilder and Marie Newton. *(Seaton Library)*

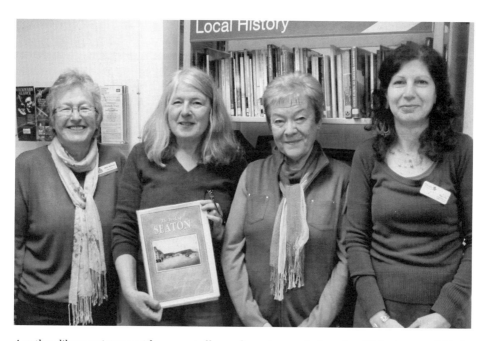

Another library picture with more staff members, two as before plus Jill Jackson and Merle Vanstone. *(Seaton Library)*

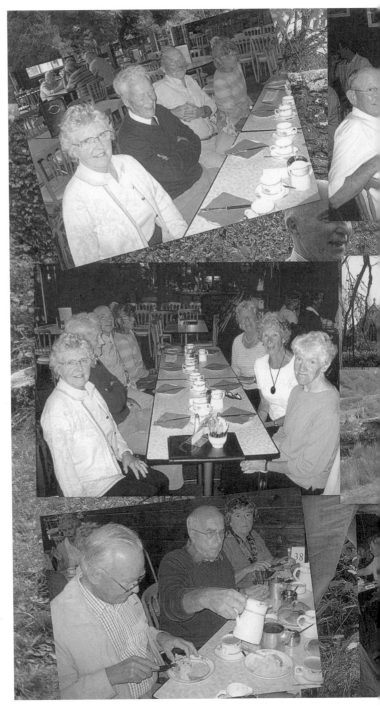

Over the past twenty-two years Seaton Museum Curator Ted Gosling has organised over 120 coach trips to various parts of the West Country. This collage of photographs taken by a member on Sunday 11 September 2011 shows members of the Axe Valley Heritage Association enjoying a cream tea in Badgers Holt restaurant at Dartmeet following their coach trip to Dartmoor. *(Seaton Museum)*

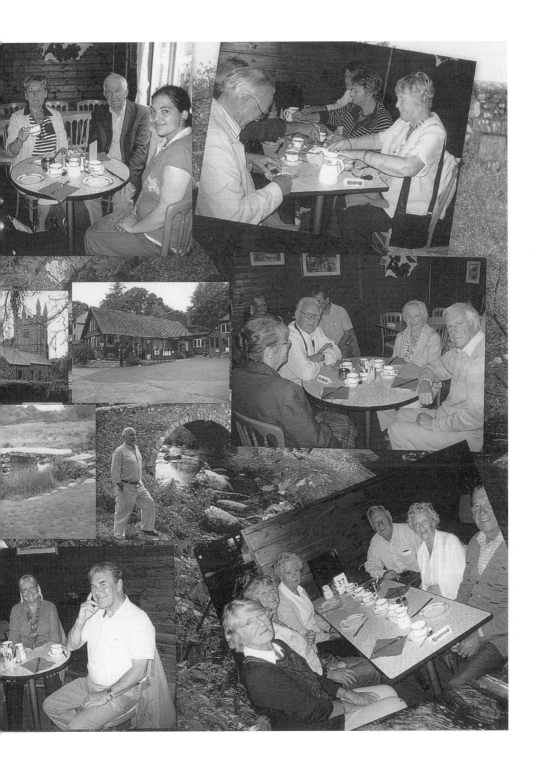

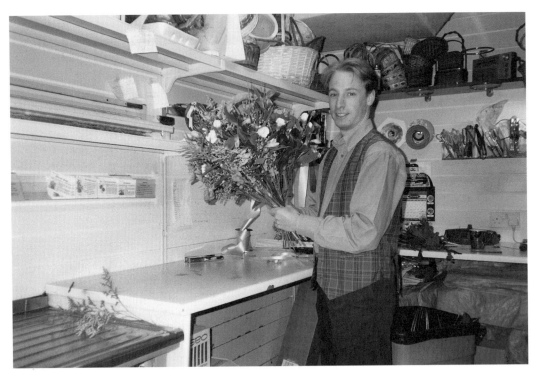

Above: Mark Hammett is pictured here in his shop, Just Flowers, now one of the most successful and attractive shops in Seaton. Mark is a member of the Clapps dynasty and Just Flowers opened in October 2001. *(Mark Hammett)*

Left: Phillip Higginson, former town clerk of Seaton, was a Boltonian by birth and his service with the Royal Marines brought him to East Devon in 1961. Phillip was a most efficient town clerk and was always a very courteous and helpful man. *(Seaton Museum)*

2

HONOURS
WELL DESERVED

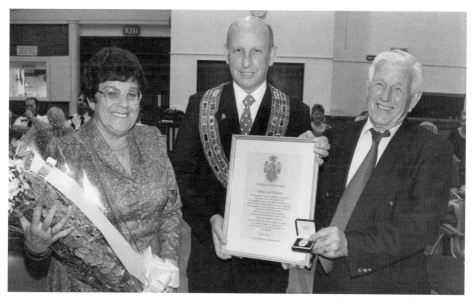

Desmond Garratt had a varied career in the Second World War and after. Serving as a town
councillor for over thirty years, he became one of Seaton's most popular personalities and
an individual who always put service before self. Des is seen here, with wife Daphne, being
presented with a gold medal and a framed inscription by the Town Mayor David Jackson
in May 2000. The framed inscription bears the words 'Thank you Desmond Garratt . . .
in recognition of your unbroken service as a councillor . . . your unselfish citizenship as a
fireman and for raising funds for Cancer Research'. *(Colin Bowerman)*

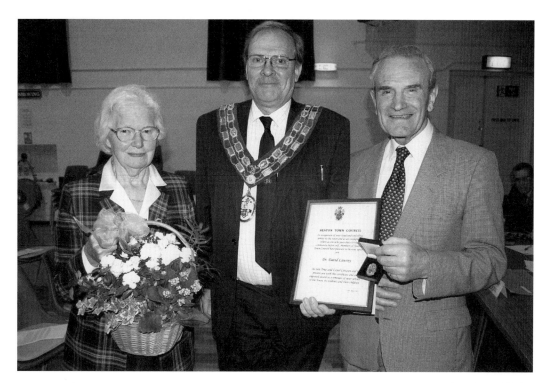

At a special presentation at Seaton Town Hall, retired GP David Lawrey was awarded Town Citizen of the Year in May 2007. Detailing Dr Lawrey's contribution to the town over the past forty-six years, Mayor of Seaton John Meakin said he was a valued and much-loved citizen who had practised medicine in the town since 1961. Before coming to Seaton he worked at Bideford Hospital where he was the only hospital doctor. He was always calm and dependable, especially during a crisis. The mayor added that with Dr Bob Jones he had been instrumental in the building of Seaton Hospital and was president of the Hospital League of Friends. Mayor John Meakin is pictured here making the presentation to Dr David Lawrey and also presenting a floral basket to his wife Betty. *(Colin Bowerman)*

Opposite, top: Dennis Morgan, over the years, has supported more causes in Seaton than anyone else. Dennis, the President of the Seaton and District Lions, is pictured here in 2005 receiving the Melvin Jones Fellowship Award from district governor Brenda Wood for his services to the Lions Club International. Well done that man!

Opposite, bottom: National Blood Service co-ordinator Steve Sugden (second right) is pictured making a presentation to Eileen Mutter (Lan) for organising blood donor sessions at Seaton Town Hall for the previous fifty years. Also pictured are Roy Scrivener (local co-ordinator) and Jean Hanniford, Lan Mutter's assistant. *(Colin Bowerman)*

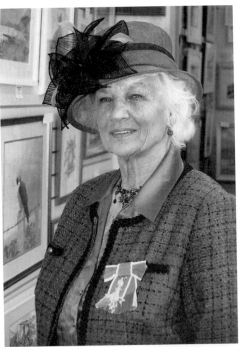

A well-deserved recognition: Ursula Pratt was awarded the MBE for her charitable work in East Devon. Ursula, who runs an art gallery in Seaton, has raised more than £170,000 for charity over the past twenty years. *(Colin Bowerman)*

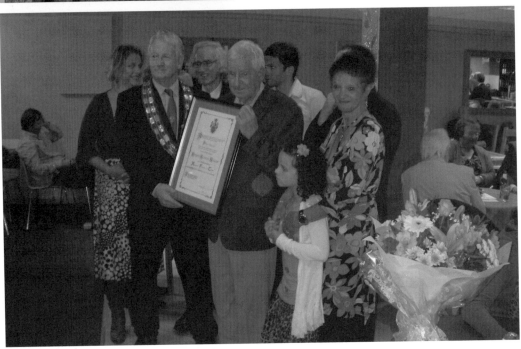

Ted Gosling, pictured here with his wife Carol, granddaughter Tallulah, daughter Melanie, grandson Kane, son-in-law John Finnigan and John's father Tom, is being presented with a framed award by Town Mayor Peter Burrows, making him the first Freeman of Seaton. Cllr Burrows told the gathering of over seventy relatives and friends that for the past seventy years Ted had been involved in numerous organisations in Seaton but has been best known for his work in establishing Seaton Museum. *(Geoff Marshall)*

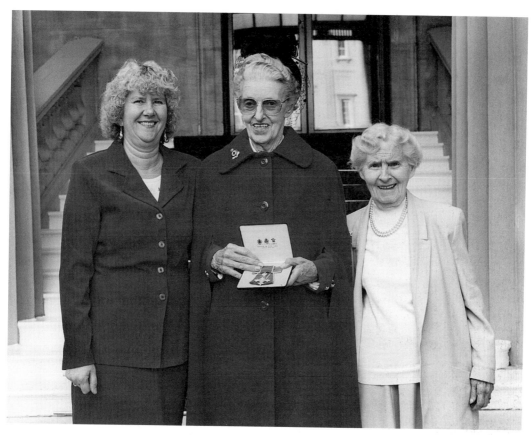

Miss Eileen Mutter (centre), known to friends as Lan, received an MBE in the Queen's Birthday Honours List of 2000 for services to the Blood Transfusion Service and the British Red Cross Society in Seaton. She was invested by the Prince of Wales on 24 November that year. Lan sadly passed away on 23 December 2011. Also pictured here are Angela Broom and Betty Mutter. *(Lan Mutter)*

✳ ✳ ✳

At the time of writing it has been sixty years since George VI died and his daughter Elizabeth became queen. Far away are those years and much has changed, although Axmouth still remains a true Devon village where old community spirit is very much alive. It has also avoided a large influx of newcomers and is fortunate that the ones who have arrived here have entered wholeheartedly into the local community spirit.

Seaton, on the other hand, has changed beyond recognition and many of the old Seatonians featured in this book have passed away. The Seaton railway branch closed on 5 March 1956 – a very sad day for the town – and the Regal Cinema closed and was demolished in 1975. Among the other significant changes during the past sixty years are the closure of all the major Seaton hotels and that of both holiday camps. As a result Seaton has changed from a holiday resort into a residential town and many of the lanes, fields and open spaces which surrounded the town have been built-up with housing estates.

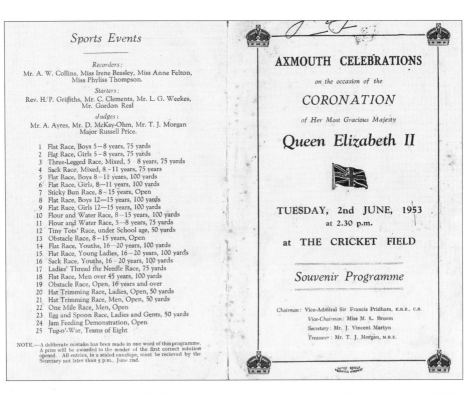

Sports Events

Recorders:
Mr. A. W. Collins, Miss Irene Beasley, Miss Anne Felton,
Miss Phyliss Thompson.

Starters:
Rev. H. P. Griffiths, Mr. C. Clements, Mr. L. G. Weekes,
Mr. Gordon Real

Judges:
Mr. A. Ayres, Mr. D. McKay-Ohm, Mr. T. J. Morgan
Major Russell Price.

1 Flat Race, Boys 5—8 years, 75 yards
2 Flat Race, Girls 5—8 years, 75 yards
3 Three-Legged Race, Mixed, 5—8 years, 75 yards
4 Sack Race, Mixed, 8—11 years, 75 yards
5 Flat Race, Boys 8—11 years, 100 yards
6 Flat Race, Girls, 8—11 years, 100 yards
7 Sticky Bun Race, 8—15 years, Open
8 Flat Race, Boys 12—15 years, 100 yards
9 Flat Race, Girls 12—15 years, 100 yards
10 Flour and Water Race, 8—15 years, 100 yards
11 Flour and Water Race, 5—8 years, 75 yards
12 Tiny Tots' Race, under School age, 50 yards
13 Obstacle Race, 8—15 years, Open
14 Flat Race, Youths, 16—20 years, 100 yards
15 Flat Race, Young Ladies, 16—20 years, 100 yards
16 Sack Race, Youths, 16—20 years, 100 yards
17 Ladies' Thread the Needle Race, 75 yards
18 Flat Race, Men over 45 years, 100 yards
19 Obstacle Race, Open, 16 years and over
20 Hat Trimming Race, Ladies, Open, 50 yards
21 Hat Trimming Race, Men, Open, 50 yards
22 One Mile Race, Men, Open
23 Egg and Spoon Race, Ladies and Gents, 50 yards
24 Jam Feeding Demonstration, Open
25 Tug-o'-War, Teams of Eight

NOTE.—A deliberate mistake has been made in one word of this programme.
A prize will be awarded to the sender of the first correct solution
opened. All entries, in a sealed envelope, must be recieved by the
Secretary not later than 5 p.m., June 2nd.

AXMOUTH CELEBRATIONS

on the occasion of the

CORONATION

of Her Most Gracious Majesty

Queen Elizabeth II

TUESDAY, 2nd JUNE, 1953
at 2.30 p.m.

at **THE CRICKET FIELD**

Souvenir Programme

Chairman: Vice-Admiral Sir Francis Pridham, K.B.E., C.B.
Vice-Chairman: Miss M. L. Broom
Secretary: Mr. J. Vincent Martyn
Treasurer: Mr. T. J. Morgan, M.B.E.

The cover of the programme for the queen's coronation celebrations, Axmouth, 2 June 1953.

Opening Ceremony

National Anthem

Hymn - "All People that on earth do dwell"
Scripture Reading - Mr. S. Partridge
An Address - Bidding to Thanksgiving, Prayer and Dedication
Thanksgiving, Intercession and Dedication Rev. Hugh P. Griffiths
Hymn - "Jesus shall reign where'er the sun"
Extempore Prayer - Mr. S. Partridge

The Lord's Prayer
The Grace

ALL people that on earth do dwell,
Sing to the LORD with cheerful voice;
Him serve with fear, His praise forth tell,
Come ye before Him, and rejoice.

The LORD, ye know, is GOD indeed;
Without our aid He did us make;
We are His flock, He doth us feed,
And for His sheep He doth us take.

O enter then His gates with praise,
Approach with joy His courts unto;
Praise, laud, and bless His Name always,
For it is seemly so to do.

For why? the LORD our GOD is good;
His mercy is for ever sure;
His truth at all times firmly stood,
And shall from age to age endure.

To FATHER, SON, and HOLY GHOST,
The GOD Whom Heav'n and earth adore,
From men and from the Angel-host
Be praise and glory evermore. Amen.

JESUS shall reign where'er the sun
Doth his successive journeys run;
His kingdom stretch from shore to shore,
Till moons shall wax and wane no more.

To Him shall endless prayer be made,
And praises throng to crown his head;
His name like sweet perfume shall rise
With every morning sacrifice.

People and realms of every tongue
Dwell on His love with sweetest song,
And infant voices shall proclaim
Their early blessings on His Name.

Blessings abound where'er He reigns;
The prisoner leaps to lose his chains;
The weary find eternal rest,
And all the sons of want are blest.

Let every creature rise and bring
Peculiar honours to our King;
Angels descend with songs again,
And earth repeat the loud Amen.
Amen.

Announcements by the Secretary

The singing will be led by the Choir of the Parish Church and others.

NOTE.—If wet the Opening Service will be held in the Parish Church.

Programme of Events

PRIZE FOR DECORATED HOUSE
Judging will take place during the fore-noon.

3.00 p.m. Chairman will unveil Seat at Waterside.

3.15 p.m. **Sports Commence** (see detailed list) and continue until late evening.

3.45 Children's Tea in Schoolroom - Free.

Presentation of Souvenir Mugs to all children of School age and under by Miss Sanders-Stephens

Adults' Free Tea
Owing to lack of accomodation this has to be divided into two parts.

4.30 p.m. (1st Session).

5.30 p.m. (2nd Session).

8.30 p.m. Social in School.

9.00 Broadcast Speech by Her Majesty
Queen Elizabeth II.

10.00 p.m. **Bonfire on Hawkesdown.**

FINIS

GOD SAVE THE QUEEN

The General Committee of the Axmouth Coronation Celebrations takes this opportunity of thanking parishioners for their generous response to the appeal for funds which amounted to a sum in excess of the target. It is sincerely hoped that the enjoyment provided will be sufficient reward for this generosity. A Public Meeting will be held in due course at which the Balance Sheet will be presented.

Best thanks are given to the Organisers of the various fund raising events, to the Collectors and ALL who have given time and much effort in the preparation for these celebrations. Special thanks are also due to those Ladies and Gentlemen who will be working hard on the day itself.

The programme of events for the celebrations.

3

AXMOUTH

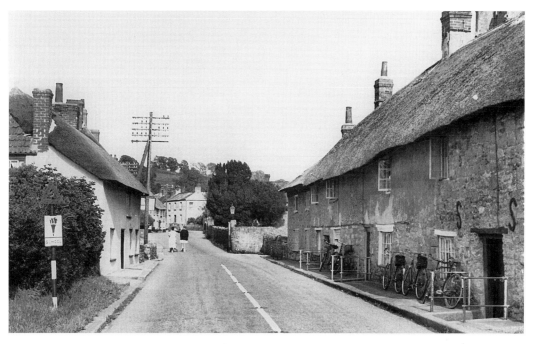

This photograph of Axmouth village in about 1953 evokes many happy memories of childhood in the village. The old thatched cottages on the right housed Eddy and Gladys Spiller, Emma Critchard, Sidney and Annie Humphrey, Enid Owen and Stanley Morgan. The thatched cottage on the left was occupied by Henry and Alice Critchard. Henry Critchard made coffins in the village. The Harbour Inn landlord back then was Ludovic Grant. Note the school sign on the grass verge to the left. The school closed in 1959.

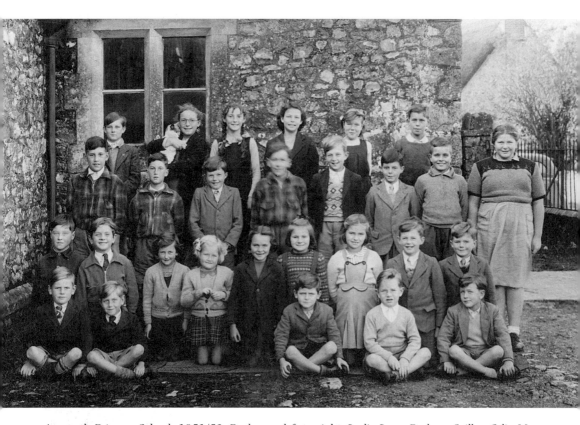

Axmouth Primary School, 1951/52. Back row, left to right: Leslie Legg, Barbara Spiller, Celia Morgan, Pauline Real, Jennifer Nash, David Vaughan. Middle row: Brian Tipper, Robin Legg, Keith Dack, Michael Sweetland, Alan Johns, Bruce Dack, Albert Snell, Rosemary Spiller. Front row, kneeling: Keith Nash, Tony Widger, Susan Webber, Shirley Newbery, Gwen Ostler, Sandra Key, Jean Johns, Maxwell Dack, Sandy Dack. Front, cross-legged: Ronald Real, Michael Clement, John Squance, Rodney Morgan, Clifton Real.

Axmouth Sunday coach outing to Bude, *c.* 1952. Left to right are Ron Real, Robin Legg and Bob Tucker.

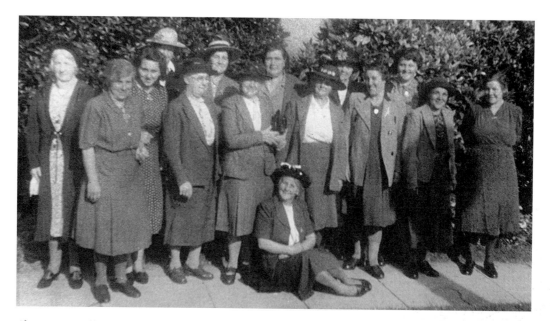

Above: Mrs Griffiths' Axmouth outing, 1950s.
Left to right: Rose Real, May Tucker, Emma Johns,
Elizabeth Clement, Mrs Horne, Laura Clement,
Mrs Hudson, Mary Webber, Suzy Soper,
Ada Ayres, Alice Larcombe, Winifred Maidment,
Esther Snell, Amelia Newbery. Sitting in front
is Dora M. Griffiths, the wife of the vicar of
Axmouth.

Right: A village day out from Axmouth. Miriam
Legg and her father, Tom Tipper, are dressed in
their Sunday best for a coach outing in the 1950s.
Such was the excitement surrounding this trip,
it was talked about in the village well before the
event and then for weeks after!

Axmouth boys Tom Tipper, Gerald Legg and Charlie Harvey enjoyed a Sunday coach outing to Lynton and Lynmouth in the 1950s. These trips were always popular with the locals.

Axmouth Primary School, 1954. Back row, left to right: Sandra Key, Keith Dack, Robin Legg, Tony Widger, Jean Johns. Middle row: Sandy Dack, Frankie Beer, Michael Clement, Jeannette Spiller, Rodney Morgan, Ronald Real, Clifton Real. Front row: Keith Millman, Melvin Millman, Carole Widger, Janet Newbery, Carol Key, Shirley Newbery, Keith Legg.

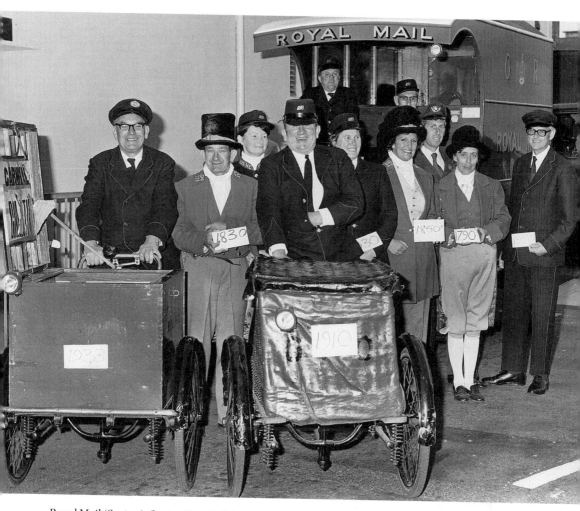

Royal Mail (Seaton), Seaton Carnival, 1977. Left to right: Len Down, George Fry, Doris Clement, Jack Hiscox, Olive Hutchings, Barbara Sharpe, Mike Clement, Sylvia Parsons, Gerry Rogers and on the vintage vehicle, Gilbert Hutchings and Les Ball.

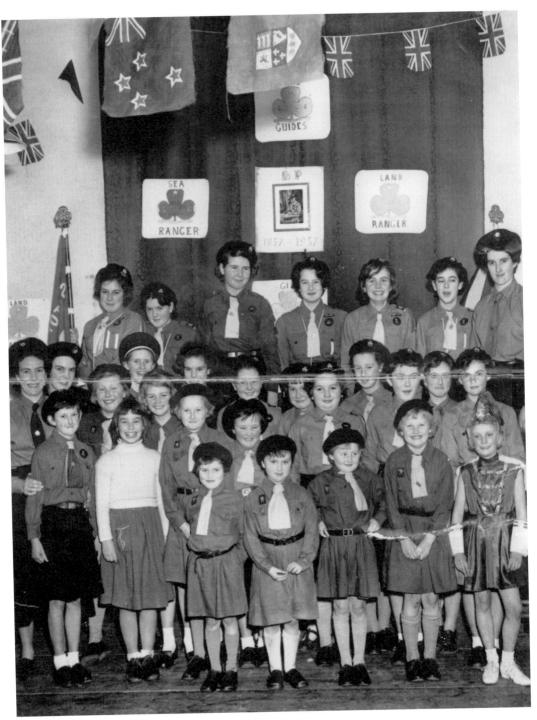

Seaton Guides and Axmouth Brownies, *c.* 1957. Among those known, from back to front, are: Wendy Hancock, Rosemary Ball, Joy Hansford, Ann Skinner, Margaret Northcott, Ann Real, Angela Poole, Janet Williams, Susan Webber, Jeanette Spiller, Carole Widger, Joan Coburn, Shirley Newbery, Sandra Hammett, Monica Clement, Carol Hoare, Ann Newbery, Janet Newbery, Stella Soper.

Brian Tipper is seen here at his aunt's home, 4 Elm Orchard, Axmouth, in the 1950s.

Axmouth old school, *c.* 1964. Miss Bustle, Guide leader, is first on the left. Sea Rangers in the middle include, Janet Newbery, Celia Morgan, Margaret Northcott, Hillary Pavey and Monica Clement. Mavis Williamson is on the extreme right of the Guides.

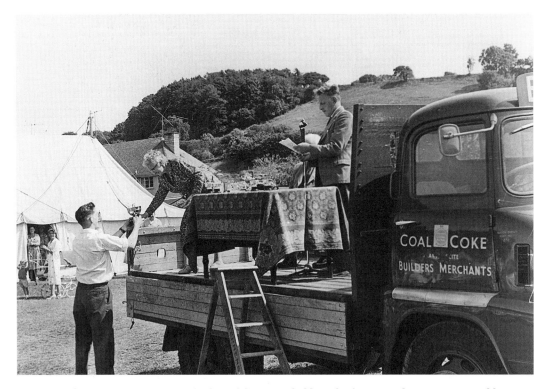

During the 1950s and '60s Axmouth Flower Show was held on the first Saturday in August and here, on the old cricket and football field, a Bradford's coal lorry is being used as a stage for the presentation of cups and other prizes. Herbie Sweetland is being presented with a cup by Mary Broome of Coombe Farm, while Jim Cross is making the announcement to the spectators.

The Harbour Inn, *c.* 1967. In the foreground are Ethel and Herbie Clement, Andy Reid, Keith Millman, Robin Legg, Sid Searle, Rodney Morgan, Gerald Morgan and Mike Clement.

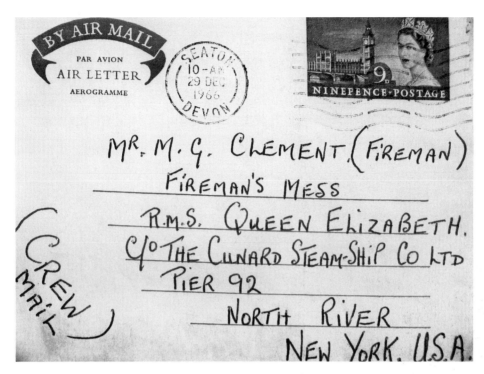

A photograph of a treasured airmail letter dated 29 December 1966. It was sent by Herbie Clement, to his son Mike Clement, who was a fireman in the engine room of the liner *Queen Elizabeth* on a passage to New York. Herbie died in 1982 aged sixty-six.

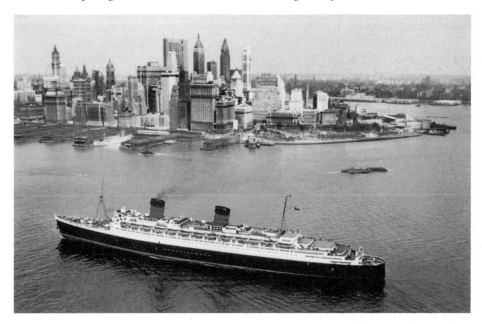

RMS *Queen Elizabeth* arriving at New York from Southampton, December 1966. She was bound for a three-week Christmas and New Year cruise of Nassau and the Bahamas, with American passengers boarding the ship at New York.

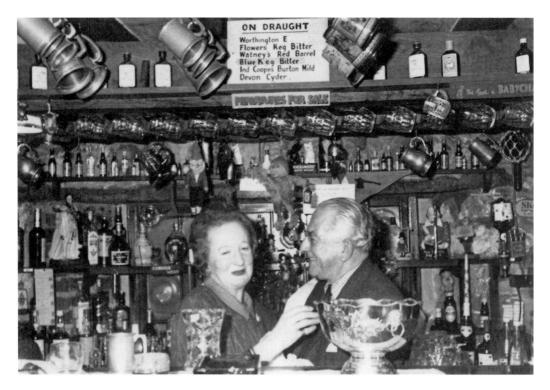

The Harbour Inn, 1968. Landlady Dorothy Rodmoore is presented with a silver bowl by Frank Sartin, on behalf of the pub clientele. Marcus and Dorothy Rodmoore were retiring from the inn to live in Seaton.

The Harbour Inn, *c.* 1967. Seen here are Andy Reed, Keith Millman, Robin Legg, Sid Searle, Terry Pavey and David Vaughan.

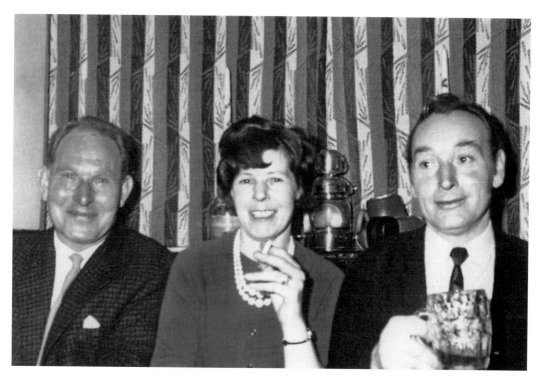

Above: The Harbour Inn, 1960s. Edward (Ned) Spiller, Barbara Morgan and Grenville Morgan.

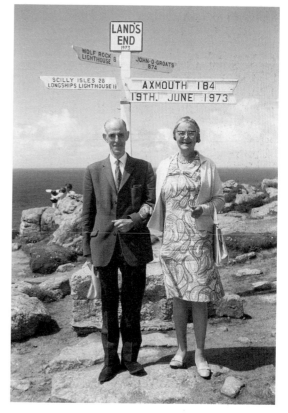

Right: Ambrose and Sheila Spiller, who ran the Axmouth post office and shop for many years. Their house was named Belle Vue and is now named Stone Cottage. This photograph was taken at Land's End on 19 June 1973, shortly after their retirement.

Lola Walton was the landlady of the Steps Country Club at Axmouth in the 1970s.

Edgar Ostler and Roy (Bimbo) Turner all set for a fishing trip out into Lyme Bay from Seaton Beach, 1970s.

Above: Gerald and Miriam Legg beside their garden at 4 Elm Cottage in the 1960s.

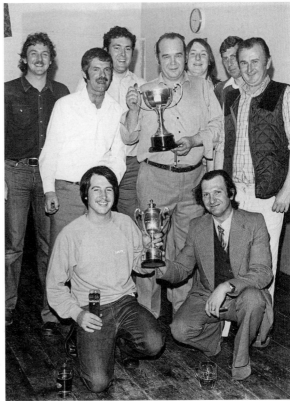

Right: The Harbour Inn darts team of the Colyton Darts League, 1970s. Seen here are Alan McLean, Bruce Dack, Chris Lord, Mick Vincent (captain), Nigel Morgan, Mike Clement, Stuart Richards, and front, Steve Bond and John Newbery.

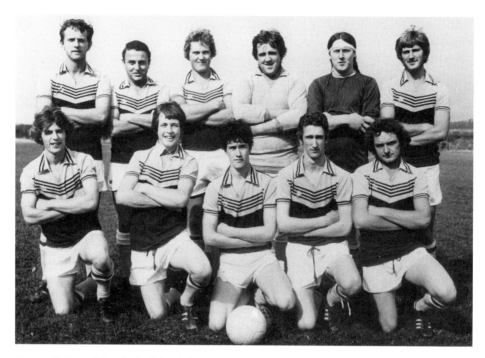

Axmouth United Football Club of the Perry Street and District Football League, late 1970s. Back row, left to right: Peter Scotchford, John Chaplin, Andrew Morgan, Nick Ostler, Nigel Morgan, John Widger. Front row: Geoff Davis, Dean Morgan, Mark Northcott, Ashley Wakley, Vincent Trevett.

Jack and Betty Jarchow, who lived at Bridge Cottage, Axmouth, which was the old tollhouse on the bridge. This photograph was taken in the 1980s.

Young Axmouth United supporters at Crewkerne School football ground, *c.* 1983. Left to right: Andrew Widger, Alison Scotchford, Philip Squire, Andrew Squire and Christopher Sweetland. The Perry Street and District League used Crewkerne School football pitch as a ground for men's team games.

Here are Axmouth United FC committee members Reg Hoare and Gilbert Hutchings at a fixture between Crewkerne and Axmouth in the Perry Street and District League at Crewkerne School.

The Two-Year Toddle was a sponsored walk of the landslip in 1984, from Ware Cross to Axmouth. This photograph shows the outgoing trip by tractor and trailer going through Axmouth Village heading for Ware Cross, just on the Rousdon side of Lyme Regis. Here we see Zoe Smith, Mike Clement, John Chaplin, Doris Clement, Pete Taylor, Di Taylor, Matthew Taylor, Francis Northcott, Tom Trezise (aged two, hence The Two-Year Toddle), Chris Sweetland, Pat Down, Nicola Pavey, Celia Pavey with her dog, and Rose Tidball. The tractor driver was Nigel Pike. The sponsored walk was in aid of Axmouth United Football Club.

John Chaplin, Doris Clement, Pete Taylor and Di Taylor, en route for the Two-Year Toddle in 1984.

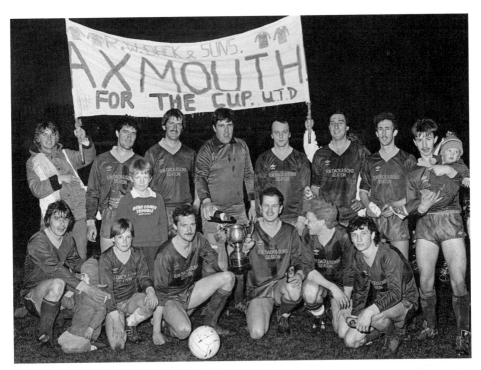

Axmouth United FC, Perry Street and District League Division Two Cup winners at Sector Lane, Axminster, 23 April 1986. They beat Charmouth 3–0, with Peter Northcott scoring two goals and Dave Harris with one. Back row, left to right: Mark Northcott, John Widger, Nick Ostler, Gary Millman, Dave Harris, Ashley Wakley, Mark Ward. Front row: Geoff Davis, Andrew Widger (with mascot Chris Sweetland behind him), Peter Northcott, Martin Richards, David Beardsall, Carl Northcott. Carole Scotchford is holding the banner on the left.

When Axmouth girl June Richards (née Sweetland), now living in Paignton, visited Australia in 1990, she met up with former Axmouth girl Barbara Key (née Youngham).

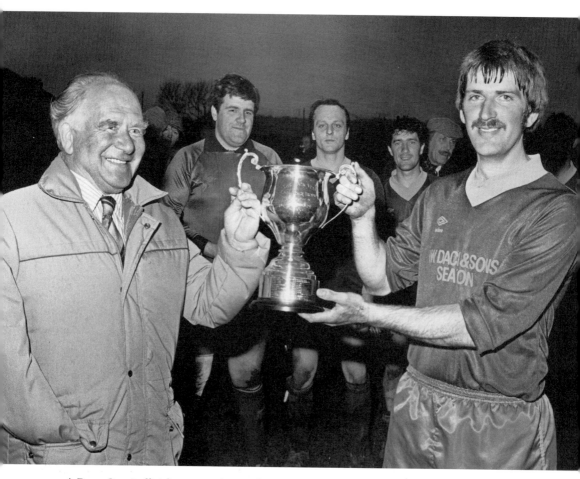

A Perry Street official presents Axmouth captain, John Widger, with the Division Two Cup at Sector Lane, Axminster, 23 April 1986. Nick Ostler, Gary Millman and Mark Northcott look on, together with Axmouth Chairman Brian Harper.

Opposite, top: Axmouth Parish Council at the opening of the new bridge between Axmouth and Seaton, 12 October 1990. Front row, left to right: Roger Webber, Cecil Williams, Arthur Ayres, Dennis Baker, Edwin Newbery, Edward Spiller. Back row: Graham Myers, David Trezise, Douglas Trevett, Mike Clement, Norman Whinfrey.

Opposite, bottom: Axmouth Parish Councillors and their wives at the opening of the bridge. Left to right: Doris Clement, Roger Webber, Nora Myers, Pat Trezise, Graham Myers, Cecil Williams, Douglas Trevett, Arthur Ayres, Evelyn Ayres, Dennis Baker, Mike Clement, Edwin Newbery, Barbara Newbery, Norman Whinfrey and Edward Spiller.

Gannet was purchased by Nigel Daniel in 1990 from the breakers' yard in Southampton. She was an open rowing lifeboat and the date of her build was 18 January 1955, which was carved into her stern. She was brought back to Axmouth where Paul Mears carried out the unusual expert process of fitting a transom stern to the double-ended boat. This was (and is) a requirement in order to race in the Beer Luggers summer series. She was launched at Axmouth in May 1991 for the start of the summer racing. Launching *Gannet* are Jack Daniel, Nigel Daniel, David Trezise, David Mettam and Tom Bridgeman.

The winning crew of *Gannet* at Beer Regatta in August 1991 are Nigel Daniel, David Trezise, Aidan Winder and Tom Bridgeman. The crew also sailed Nigel Daniel's cruiser *Toroa of Axe* in the follow-on afternoon race and also won that, hence all the cups.

Right: Andrew Widger at Plymouth Argyle Football Club, early 1990s.

Below: Graham Myers of Haven Cottage is seen here at Axmouth Village Show, August 1990.

Axmouth Flower Show golden jubilee at Stedcombe, August 1993. Here we see John Trevett (left), and Jim Cross, who was one of the founder members.

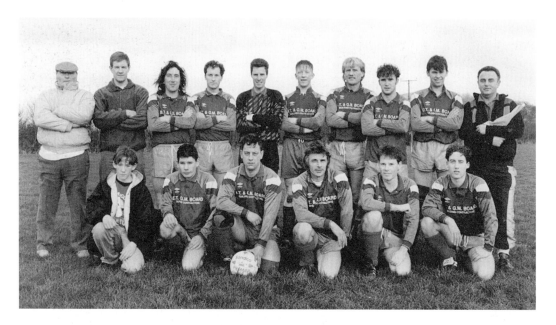

Axmouth United FC of the Perry Street and District League Division Two, season 1993/4. Back row, left to right: Grenville Morgan, Robert Sweetland, Kevin Harris, Carl Northcott, Mark Youell, Chris Sweetland, Mike Vine, Jason Pigeon, Phil Squire and John Chaplin (linesman). Front row: Chris French, Matthew Snell, David Mitcham, Geoff Davis, Grieg Dean and Creig Alexander.

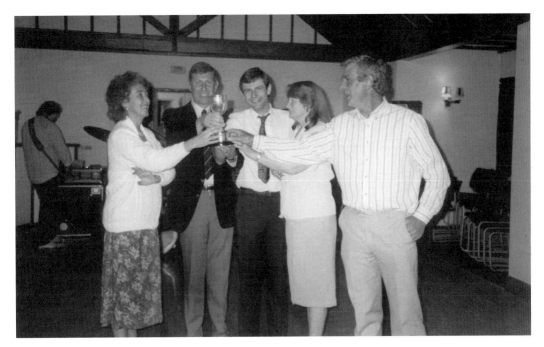

At the Harbour Inn in the 1990s Tony Widger (Axmouth reserve team manager) and his wife Liz, and Mike Clement (reserve team linesman) and his wife Doris, present the brand new Herbie Clement Memorial Cup to the reserve team's first winner, Andrew Trott.

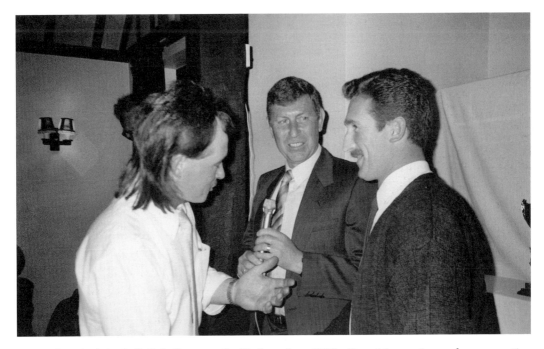

Axmouth United Football Club dinner at the Harbour Inn, 1990s. Dean Morgan is seen here presenting Ashley Wakley with the Lisa Marie Morgan Cup.

Another football club dinner at the Harbour Inn in the 1990s. Reserve team manager Tony Widger shares a laugh and a joke with Anita Rolls.

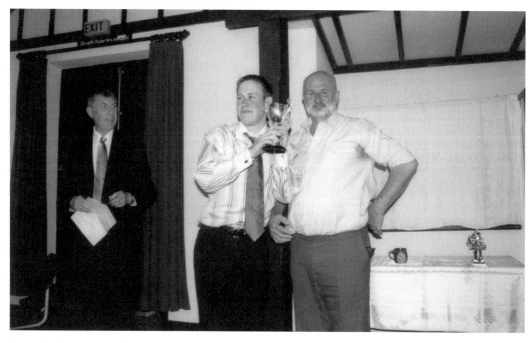

Football club dinner and presentation night at the Harbour Inn, 1990s. Club chairman Ross Dack presents Tim Vincent with the Geoffrey Spiller Memorial Cup.

The age-old tradition of burning the ashen faggot takes place at the Harbour Inn, Axmouth, every Christmas Eve, and always to a packed house. In this photograph the faggot has been placed on the open fire and is starting to burn while the traditional singing starts, led by, from the left, standing, Phil Gamble, Ian Hunt and David Trezise.

Axmouth United annual dinner at the Wheelwright Inn, 2003. Left to right: Carl Northcott, Frances Northcott, Sue Goddard and Paul Northcott.

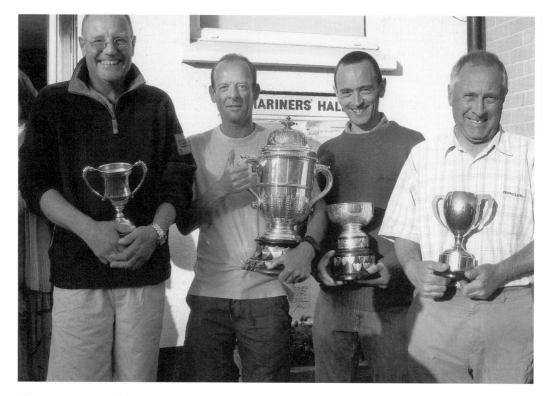

The winning crew of *Gannet* at the 2006 Beer Regatta were David Trezise, Nigel Daniel, Matthew Taylor and Peter Taylor.

At the Donkey Sanctuary near Sidmouth, 1990s. On the left is Elizabeth Gush and on the right Edith Brown, both from Axmouth.

Axmouth United club dinner at the Wheelwright Inn, Colyford, 2003. Ann and Mervyn Joslin are caught on camera.

Axmouth United club dinner at the Wheelwright Inn, 2003. In this group are Stuart French, Carl Northcott, Shaun Waddon, Sam Bastin, Keith Kellam and Chris Hammett.

Axmouth United club dinner, at the Harbour Inn, 2002. Richard Voysey has been presented with one of the club's trophies by manager Mervyn Joslin.

Axmouth United Football Club's ground at Musbury Road, *c.* 2005. The winning five-a-side football team from Seaton can be seen holding the Geoff Davis Memorial Shield.

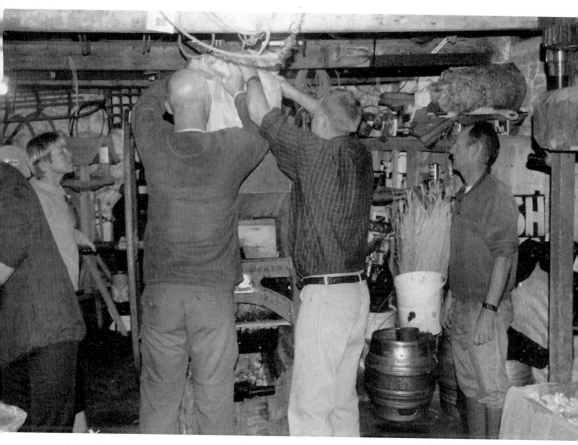

Cider-making in the barn belonging to Steps House. Jane Calvert, Chris Davies?, David Trezise and Nigel Daniel are seen hard at work in November 2005.

Above: Eleanor Moore of Axmouth Women's Institute celebrates her ninetieth birthday in 2003 with President Olive Owen.

Left: Mike and Doris Clement at St Michael's Church, Axmouth, 2009.

At Little Thatch in 2006 and waiting to depart for the Harbour Inn and the village hall committee annual dinner are Shane Smitham, Lindsay Smitham, Alison Underwood and Jonathan Underwood.

A Women's Institute workshop at Axmouth Village Hall, December 2006. Ladies of Axmouth WI are pictured here, left to right: Pam Barnard, Yvonne Hines, Katherine Ord-Smith, Wendy Laken, Peggy Redgrave, Betty Board, Olive Owen, Janet McKenzie, Eileen Juster, Alison Morris and Carol Smith.

At the back of Steps House, Mike Calvert, Ian Hunt, Brian Davis and David Trezise prepare the ashen faggot with hazel binding. The Harbour Inn holds the annual Christmas Eve ceremony of burning the ashen faggot on its open fire.

Burns Night at the Harbour Inn, 2007. The bar staff Nick Ostler and Liz Brown are dressed for the occasion.

Burns Night at the Harbour Inn, 2007. Here we see Alix Fairley and the landlord Gary Tubbs.

Burns Night 2007 at the Harbour Inn. Doris Clement, Malcolm Henty and Carol Smith.

Above: Gary and Graciella Tubbs, landlord and landlady of the Harbour Inn at Axmouth, celebrate Burns Night in 2007.

Left: At Little Thatch, Axmouth, are Christine Badger and Ken Steven, 2007.

The Harbour Inn A boules team annual dinner at the Harbour Inn, *c.* 2007. From left to right: Pete Scotchford, Christine Badger, Carol Smith, Richard Gush, Sandra Henty, Malcolm Henty, Doris Clement, Mike Clement, Ron Badger, Pete Butler, Rosalind Butler, Wilf Gribble.

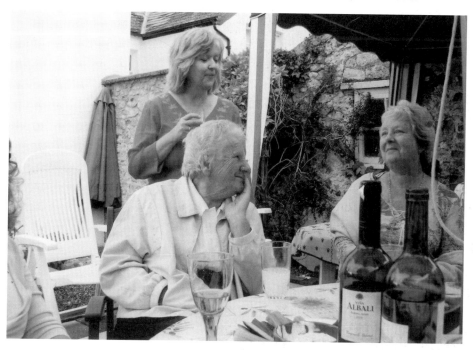

At Brookhouse we see Georgie Pigeon and Rosalind Butler (centre) with Gill Crowe, on a warm summer's evening, June 2007.

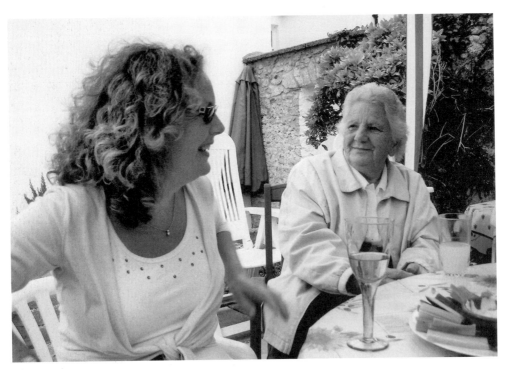

More guests of Rosalind and Peter Butler at Brookhouse in June 2009. The photograph shows Morag Steven and Georgie Pigeon.

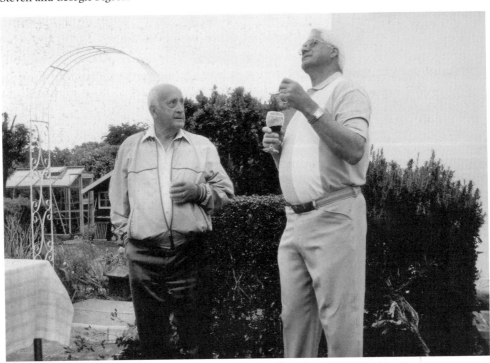

A summer evening at Brookhouse, June 2007. Ira Pigeon and John Crowe are seen here.

Right: Sandra and Malcolm Henty of Monkswood, Steps Lane.

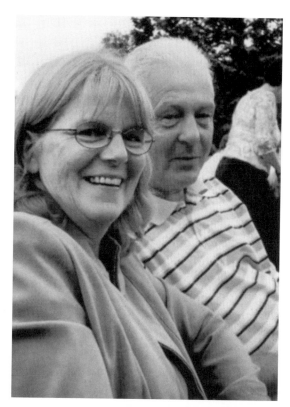

Below: Jean Seward, Nancy Sweetland, Ann Perry and Donald Mariner at Trafalgar night celebrations in Axmouth Village Hall, October 2007.

The Harbour Inn C skittles team – Colyton League Division II winners, 1990/91. Left to right: James Thresher (sticker-up), Dean Hancock, Harry Thresher, Gary Somers.

The Harbour Inn C skittles team on the same occasion. Left to right: Herbie Sweetland, Mike Clement, Nick Ostler, James Thresher, Harry Thresher, Peter Scotchford (captain), Dean Hancock, Gary Somers.

The Harbour Inn C skittles team, Colyton Skittles League Knockout Cup winners, 2008/9. Back row, left to right: Nick Ostler, Chris Brown, Richard Gush, Eric Pomeroy. Front row: Mike Clement, Pete Scotchford (captain) and Mervyn Joslin.

Harbour A skittles team at the Harbour Inn, Friday 20 January 2012. From left to right: Mark Pavey, Peter Ives, Robert Sweetland, Dave Minchin, Andrew Spiller and Neil Widger. At the front is Luke Sweetland, the sticker-up.

Ethel Clement and Matthew Yates (grandmother and grandson) at Coldwell Lane, Axmouth.

Manning the water station at Gays Farm, Branscombe, for the 2012 Grizzly Run are Danny Gates, Mike Clement, Carol Smith, Denise Gates, Wilf Gribble and Doris Clement.

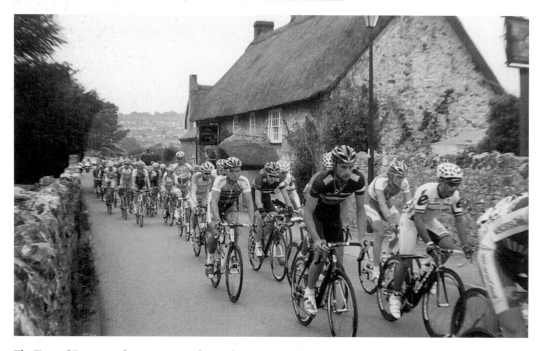

The Tour of Britain cycle race passing the Harbour Inn, Friday 18 September 2009. This was stage seven of the race from Hatherleigh in North Devon to Yeovil in Somerset.

Above: Three former Chairmen of Axmouth Parish Council on Axmouth Bridge. Left to right: Dennis Hall (2002–10), David Trezise (1999–2002) and Arthur Ayres (1987–95).

Right: The late Sir John Loveridge and Lady Loveridge. They are pictured here together outside their home, Bindon Manor. Bindon stands in a delightful setting and has a long and interesting history as well as a close association with St Michael's Church at Axmouth.

The cast of *Cinderella*, Axmouth Children's Theatre, February 2009. Back row, left to right: Luke Sweetland, Jonathan Sweetland, Jared Steven, Rosie Hall, Dennis Hall. Middle row: Bethany Wood, Taylor West, Devon Foster, Amy Harris, Megan Spiller, Sam Harris, David Goodhew, Thomas Broderick. Front row: Annie Beavis, Lauren Smart, Shelby West, Ella Rapley, Jessie Spiller, Seebra Young, Victoria Herrity and Amiya Young.

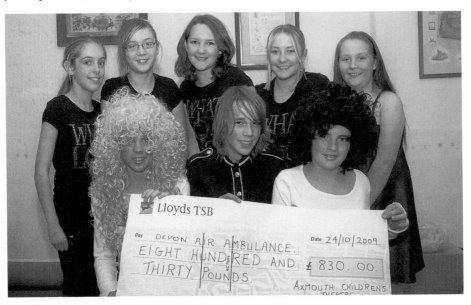

Axmouth Village Hall, October 2009. The young folk of the Axmouth Children's Theatre are seen here with a cheque for the Devon Air Ambulance. Back row, left to right: Devon Foster, Taylor West, Megan Spiller, Amy Harris, Shelby West. Front row: David Goodhew, Jared Steven, Sam Harris.

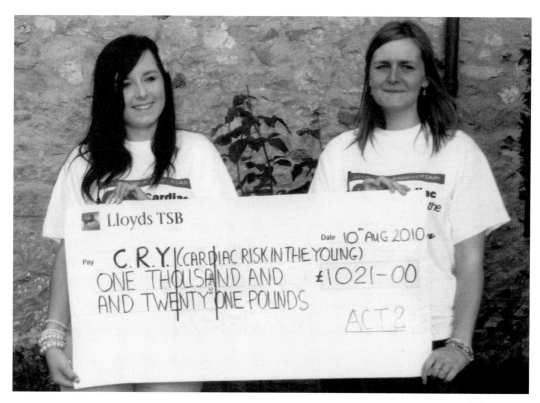

Above: Sisters Kate and Alison Ostler hold a cheque for the charity CRY (Cardiac Risk in the Young), which was presented by Axmouth Children's Theatre 2. Kate and Sarah's mum Alison was a victim of this syndrome.

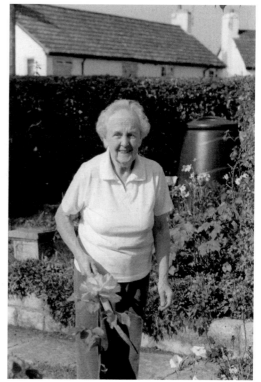

Right: Nora Myers at her Haven Cottage garden, Axmouth, 2011.

New Year's Eve at Little Thatch, 2009. Left to right: Jill Udy, Sandra Henty, Mary Britton, Paul Britton, Terry Loveridge, Carol Smith, Malcolm Henty, Wilf Gribble, Doris Clement, Mike Clement, Alan Coomber.

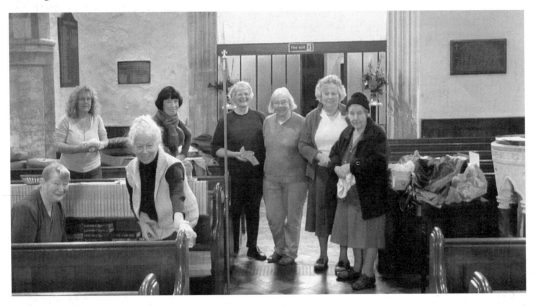

Friends of Axmouth Church, seen here cleaning the interior of St Michael's Church, December 2011. The workers are Doris Clement, Hillary Harron, Morag Steven, Sarah Johnson, Rose Tidball, Ann Harding, Betty Board and Minnie Newbery.

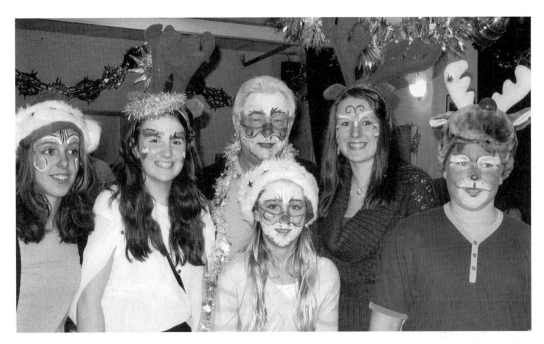

Axmouth Children's Theatre at Axmouth Village Hall Christmas Bazaar, Saturday 3 December 2011. Left to right: Devon Foster, Charlotte Coombs, Malcolm Henty, Jessie Spiller, Bethany Wood, Callum Wood.

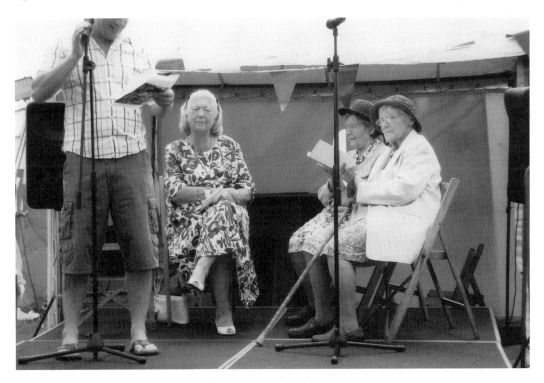

It's showtime in Axmouth in 2009. Show president Lady Loveridge (left) and Minnie Newbery and her sister Ruby Garnier (right), prepare to open the show.

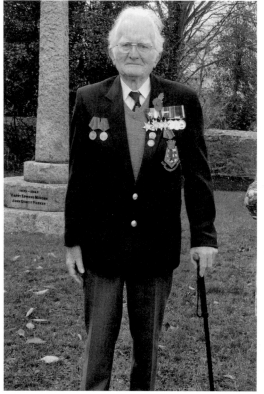

Above: At the Axmouth Parish Council meeting in the Village Hall in December 2011, we see Ken Steven, Morag Steven, Carol Miltenberg, Carol Rapley, Crescy Cannan, Irene Harrison and Keith Lawes.

Left: Raymond Board is the last surviving Second World War veteran who joined up while living in Axmouth and is still living in the village today. In 2011 Raymond placed the poppy wreath on the parish war memorial on behalf the Royal British Legion on Remembrance Sunday at Axmouth church.

Axmouth Women's Institute members are pictured here at a Christmas party, 2011. Back row, left to right: Pat Squire, Wendy Lakin, Sheila Hall, Dorothy Long, Peggy Redgrave, Norma Sweetland, Dot Heart, May Beason, Olive Owen, Pat Barnard, Betty Board, Yvonne Hines. Front row: Doreen Jones, Eileen Juster, Viv Kitt, Carol Smith, Nora Myers, Catherine Ord-Smith, Alison Morris, Barbara Newbery, Lin Allison, Hillary Mabon, Minnie Newbery, Denise Gates.

Axmouth Village Hall Christmas Bazaar, December 2009. Left to right: Hugh Morris, Ken Steven, Doris Clement, Danny Gates, Denise Gates, Betty Board, Alison Underwood, Alison Morris, Callum Wood, Richard Gush.

The Ship Inn on Burns Night, 25 January 2012. Here are Morag Steven and Alan Coomber.

A shot from the Second World War-set play *Hitler's Ear*, which was performed by the children of Axmouth Children's Theatre in 2011. Two of the cast are caught on camera – Victoria Herrity (left) and Jessie Spiller.

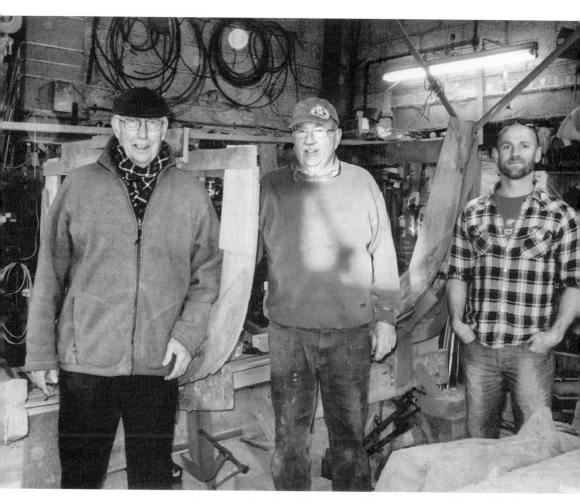

Paul Mears' boatyard, Axmouth Harbour, Friday 13 January 2012. Inside the workshop, left to right, are Douglas Spiller, Paul Mears and son Alex Mears. Paul Mears has been building boats here since 1958 and the business, worked by father and son, is still going strong.

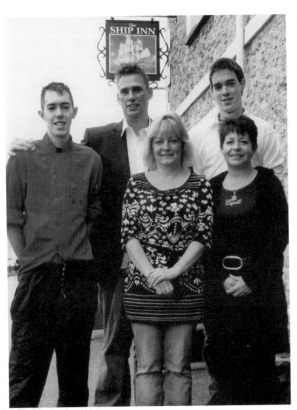

Left: Staff at the Ship Inn, Axmouth, 19 January 2012. Left to right: Matt Renshaw (assistant chef), Graham and Sarah Hill (landlord and landlady), James Goodhew (barman) and Beth Spooner (waitress).

Below: Short mat bowls in Axmouth Village Hall, December 2011. Standing, left to right: John Redgrave, Tony Johnson, Dennis Hall, Alan Coomber, Hugh Morris, Grace Gutteridge, Mike Clement, Sarah Johnson, David Webster. Seated: Nina Webster, Marie Johnson, Betty Board, Alison Morris, Peggy Redgrave.

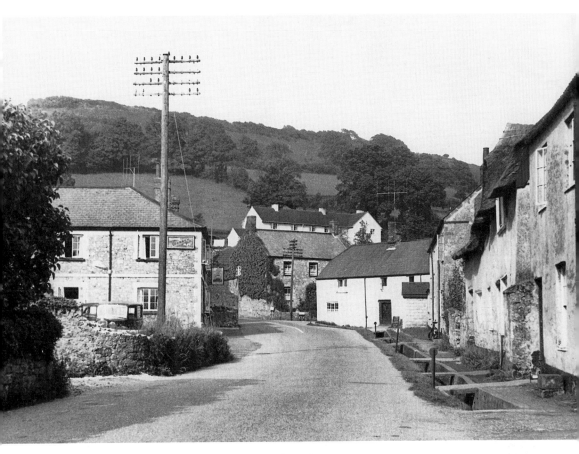

Church Street, Axmouth Village, *c.* 1953. The Ship Inn, on the left, was run by landlord and landlady Eric and Frida Childs. The first television aerials have appeared in the village by this time. Ambrose and Sheila Spiller ran the Axmouth post office on the left behind the Ship Inn, and the Newbery family, who lived at no. 38 opposite the Ship Inn, were the first to have a television set. The children of the village used to go in and watch *Children's Hour* there. The house partly covered in creeper was the home of Axmouth School's headmistress, who at this time was Phyllis Thompson. Children would lay on the grass verge by the brook to tickle trout.

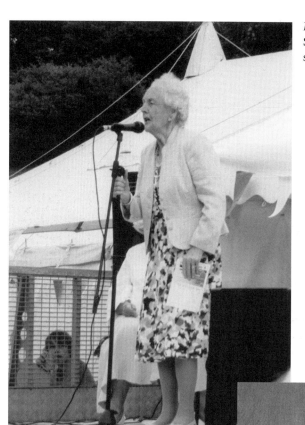

Left: The opening of the Axmouth Village Show by Mrs Nora Myers at Coombe Field, summer 2010.

Right: Julie Spiller is the mother of Megan and Jessie Spiller, who are members of Axmouth Children's Theatre, also featured in this chapter.

Burns Night at the Ship Inn, Axmouth, 25 January 2012. Left to right: Wilfred Gribble, Robert Sweetland, Penny Sweetland, Caroline Foster.

Axmouth Village Show day, 2008. Left to right: David Steele, Doris Clement, Mike Clement, Matt Yates.

Above, left: Terry Pavey at the Harbour Inn, 2 January 2012. He played football for Axmouth United and worked for many years at Axminster carpet factory.

Above, right: Richard Bastin caught on camera at the Harbour Inn, 2 January 2012, is a local character. Richard loves the history of local shipping, both sail and steam, and he also owns a fishing boat. He is also a great lover of the railway engines of the Great Western, and is a frequent visitor to the Minehead preserved railway.

Left: Here we see Axe Valley Children's Centre staff on a girls' night out at the Harbour Inn, October 2010. Far right: Sue Steele, Donna Nichols, Dawn Squire and Amy Philips. On the left are Charlotte Daubney and Sally Hammond.

Meeting Robin Cousins, one of the stars of *Grease* at the Princess Theatre, Torquay, are Malcolm Henty, Carol Rapley, Anna Tidball, Julie Spiller, Ayesha Keast, Bethany Wood, Megan Spiller and David Goodhew, Saturday, 10 September 2011.

The village pantomime *Cinderella* was staged at Axminster Village Hall in February 2009. Here we have Rosie Hall as Baroness Cruella and Dennis Hall as Baron Hardup.

Axmouth Children's Theatre at the Princess Theatre, Torquay, Saturday 10 November 2011. They were on a trip to see the musical *Grease*. Back row, left to right: Chloe Yates, David Goodhew, Megan Spiller, Katie Walker. Middle row: Alice Carpenter, Shelby West, Jessie Spiller, Jack Harwood, Callum Wood. Front row: Ayesha Keast, Ella Rapley, Bethany Wood, Taylor West, Devon Foster, James Williams, Victoria Herrity.

Left: Wilfred Gribble from Little Thatch, Axmouth, relaxes with a refreshing summer drink in the garden.

Below: The 5-mile and the 10-mile Axmouth Challenge run through the village and parish took place on Sunday 8 January 2012. The senior event had a total of 103 adult participants and with thanks to the marshals, Axe Valley Runners, and the St John Ambulance service, this run proved to be a great success for Axmouth Village Hall Committee.

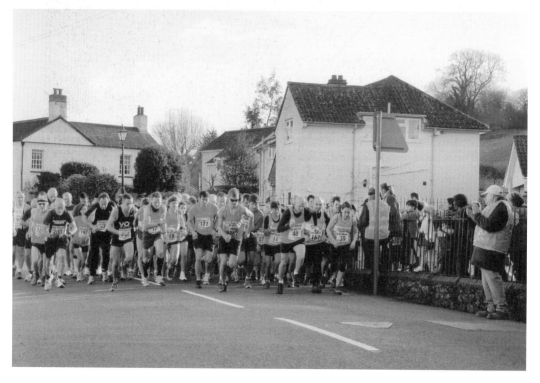

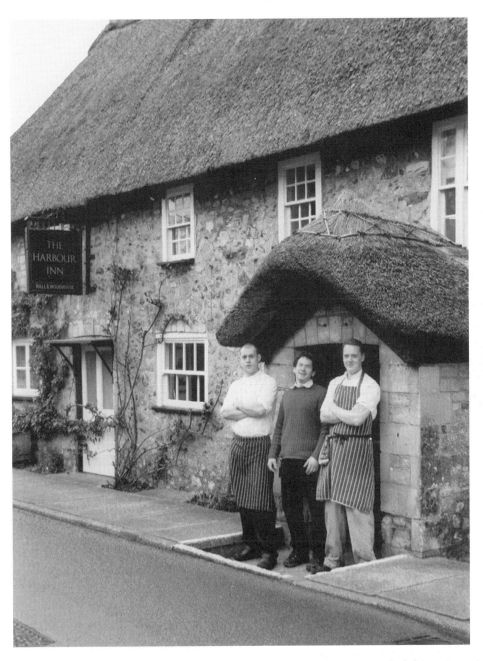

At the Harbour Inn, Axmouth, Thursday 19 January 2012. The staff, from the left, are: Gary Brooks (head chef), Jonathan Alexander (front of house and events), Edward Traynor (chef).

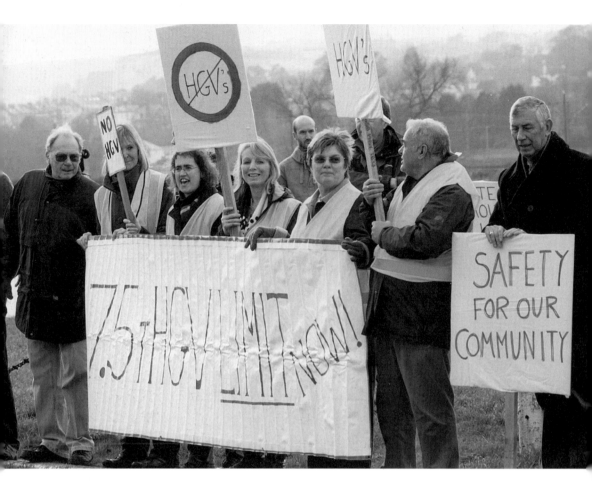

Axmouth Village protests against over-large abnormal loads of HGVs coming down over Pound Hill and Church Street during the building of the Tesco Seaton store in 2011. Left to right: Bernard Dunsford, Crescy Cannan, Alison Underwood, Carol Rapley, Mary Britton, Paul Britton and Mike Clement. (*Midweek Herald Newspaper*)

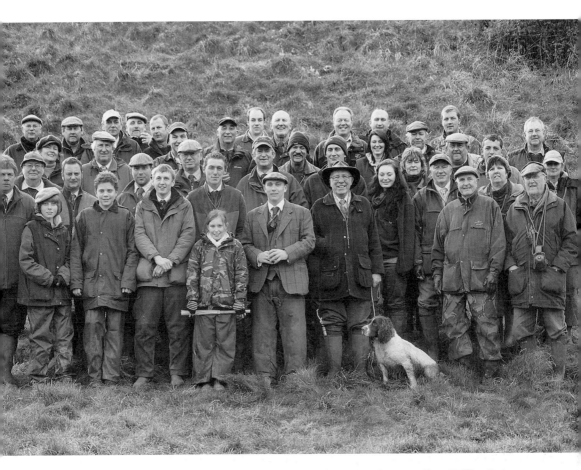

Bindon Manor Estate, beaters' shoot, January 2012. In this group shot are: Chris Kiddle, Chris Taylor, Razz Rowswell, Nigel Pike, Anthony Cross, Adam Pike, Judy Joyce, Bill Joyce, Chris Walker, Dave Minchin, Gerald Denning, Lou Thoms, Colin Thoms, Chris Davis, Mark Pavey, Mike Stone, Lindsay Smitham, Paul Nash, Martin Williams, Ian Nex, Karen Hartnell, Mike Whitting. Martin Down, Garland Pickard, Phil Crabbe, Will Pratt (gamekeeper from Powderham), Liam Hartnell, Georgina Pavey, Nicola Grellis, Ken Spiller, Jackie Wood. Front row: Morgan Down, Seth Wakley, Stuart Taylor, Becky Smitham, Shane Smitham (Bindon Manor gamekeeper), John Mills, Phil Summers, Alan Nex. *(Photograph courtesy of Jodie Hopkins)*

ACKNOWLEDGEMENTS

W e are grateful to all those people, far too many to mention individually, who have loaned or given photographs and helped make the task of putting this book together a real pleasure. We are grateful to our wives Doris and Carol for their encouragement and to Helen Newbury for her assistance in the compilation of the book. We would also like to thank Michelle Tilling from The History Press for her help and the kindness shown to us.

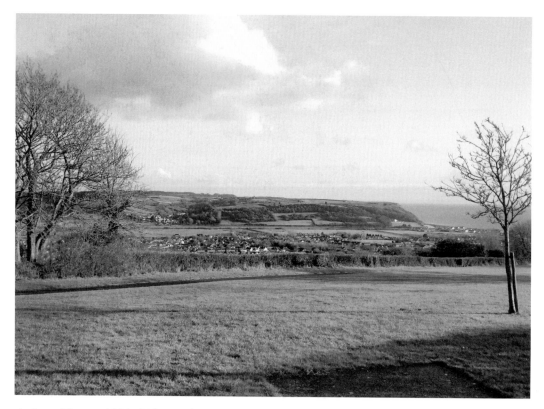

A view of Seaton, 2012. *(Helen Newbury)*